Acrylic
LANDSCAPES
IN A WEEKEND

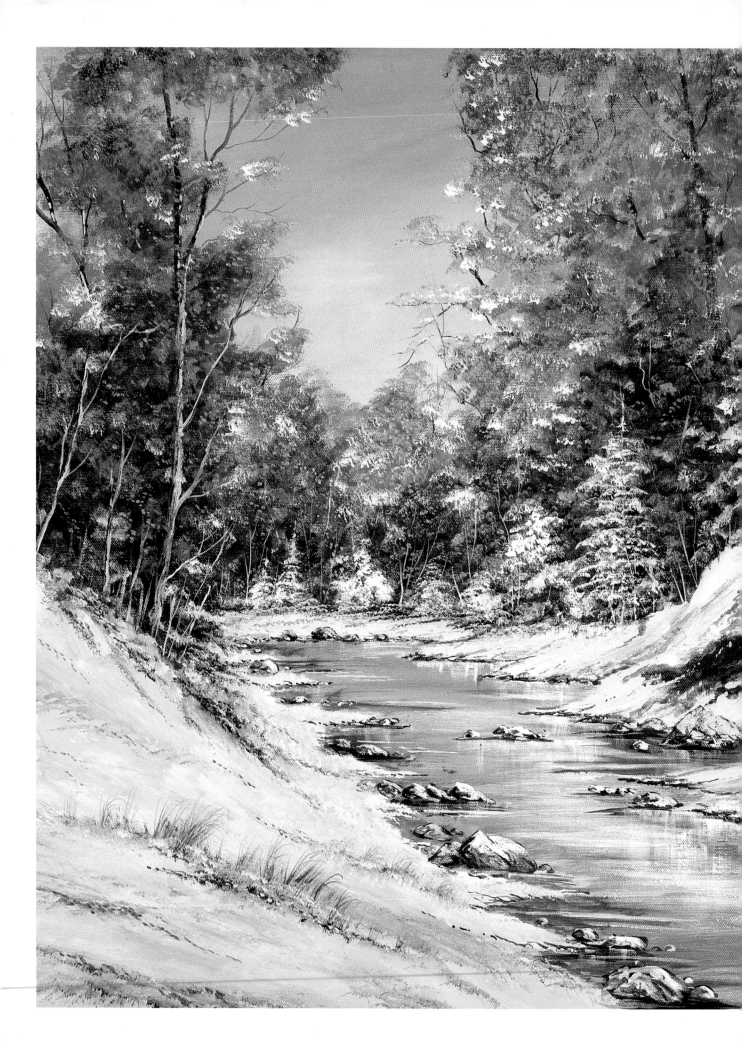

Acrylic
LANDSCAPES
IN A WEEKEND

Keith Fenwick

D&C
David and Charles

A DAVID & CHARLES BOOK
Copyright © David & Charles Limited 2009

David & Charles is an F+W Media Inc. company
4700 East Galbraith Road
Cincinnati, OH 45236

First published in the UK in 2009
First published in the US in 2009

Text and illustrations copyright © Keith Fenwick 2009

Keith Fenwick has asserted his right to be identified as
author of this work in accordance with the Copyright,
Designs and Patents Act, 1988.

A catalogue record for this book is available from
the British Library.

ISBN-13: 978-0-7153-2969-6 hardback
ISBN-10: 0-7153-2969-3 hardback

ISBN-13: 978-0-7153-2970-2 paperback
ISBN-10: 0-7153-2970-7 paperback

Printed in China by Shenzhen Donnelley Printing Co Ltd
for David & Charles
Brunel House, Newton Abbot, Devon

Senior Commissioning Editor: Freya Dangerfield
Editorial Manager: Emily Pitcher
Editor: Verity Muir
Art Editor: Sarah Clark
Designer: Sabine Eulau
Production Controller: Kelly Smith
Photographer: Kim Sayer

Visit our website at www.davidandcharles.co.uk

David & Charles books are available from all good
bookshops; alternatively you can contact our Orderline on
0870 9908222 or write to us at FREEPOST EX2 110, D&C
Direct, Newton Abbot, TQ12 4ZZ (no stamp required UK
only); US customers call 800-289-0963 and Canadian
customers call 800-840-5220.

ACKNOWLEDGMENTS

My thanks to Freya Dangerfield for believing in me and giving
me the opportunity to produce this book, to my wife Dorothy
for her support and typing of the text and to all my students
and members of the public who continuously tell me what they
expect from a book. A big thank you to Winsor & Newton/
Liquitex for their support and supplying the superb materials
used in the book.

Contents

Foreword

Throughout their long and successful history, the Winsor & Newton and Liquitex brands have developed a proud tradition of producing fine art materials of the highest quality. Artists from beginners to improvers will now have the opportunity to develop both their artistic skills and their familiarity with the product range through this exciting new book by Keith Fenwick.

Keith has had a long association with the company as a demonstrator of our products at the major fine art materials shows. The company is delighted to witness the publication of this book that achieves similarly high levels of quality and innovation. It has been my pleasure to have personally known Keith for over 20 years and I continue to be amazed by his energy, tenacity and sheer ability.

Paul Giddens
Director, Winsor & Newton

'The Old Bridge' (Acrylic on canvas)

'Summertime' (Acrylic watercolour)

When I met Keith at the International Spring Fair in Birmingham, some twenty years ago, I realized I had met someone with whom I had a lot in common. I have always strived to share my techniques with up-and-coming and fellow artists, either in person, through Master Classes, or by instructional videos/DVDs and books, because I feel it is very important to mentor new talent. Keith has followed a similar route and taken this principle much further through his popular TV programmes. I admire his drive and congratulate him. I am sure his new book will be as successful as past ventures and will introduce a new audience to landscape painting in acrylic.

John Seerey-Lester
Artist

Introduction

My aim in this book is to dispel the myths about painting with acrylics, to make the art of painting less mysterious and to show you how easy it can be – so that you can paint your first landscape this weekend.

So you think you can't paint? Well, I say you can. I don't believe painting is a gift, it's more a matter of perspiration than inspiration. I often hear people say, 'He makes it look easy and he's a better artist than we are because he's got talent.' Talent has nothing to do with it. My reply is simple, 'The harder I work, the luckier and more talented I become.' The artist who improves is one who is interested in improving.

To help build your confidence and get you started, I have devised several ways to simplify your task and get your painting under way. You don't have to learn to draw to complete the following projects: simply follow the technique on page 11 for transferring an outline of the image, and use my special aids to simplify painting techniques (see page 15). Then there's nothing stopping you painting the landscapes in this book – from beautiful waterfalls, inspiring snow scenes and tree colours to coastal scenes, woodland walks and many others. Painting is fun; I want you to enjoy yourself and be able to paint that special landscape you have always wanted to.

When I think of painting, it always brings to mind an old theatre expression – design the set, arrange the elements, then light it. It's just like painting really! The fact that you have read this far tells me that you are interested in learning to paint. I welcome the opportunity to share my experiences with you.

You can do it, if you really want to – I'll bet you can!

Happy painting,

Keith H Fenwick

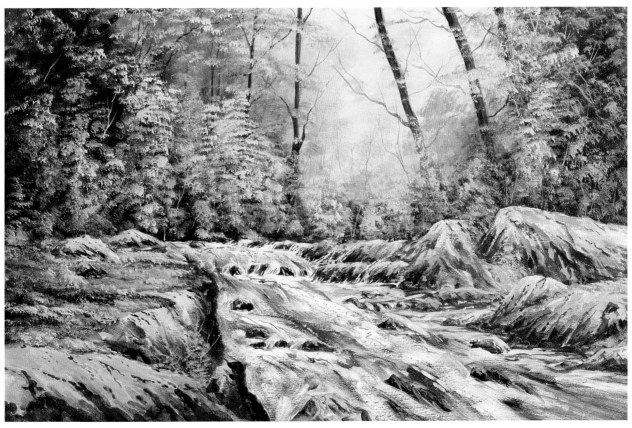

'Rocks and Running Water' (Acrylic on canvas)

Why use Acrylics?

If I were restricted to using one paint medium for the rest of my life, I would have no hesitation in choosing artists' quality acrylic paints. Acrylics are the most versatile of all paints and enable me to work as a watercolourist on watercolour paper or use oil painting techniques on canvas, and they are the ideal starter paints for beginners or improvers.

Some of the most respected painters in the world use acrylic paints to achieve effects that can't be achieved with other media, from David Hockney to my friend John Seerey-Lester, one of the world's most accomplished and renowned wildlife artists. I have been using acrylics for over 30 years and love them.

Throughout this book, I will be showing you how to use acrylics for both watercolour and oil painting techniques, and hope that, with practice, you will find the same excitement and fulfilment that I enjoy each day. Acrylic paints are the perfect choice if you are new to painting,

bringing together the best of watercolour and oil techniques but with a very forgiving nature. Acrylic really is a happy medium between the two.

PAINTING WATERCOLOURS WITH ACRYLICS

If you're not sure whether you wish to paint with watercolours or use oil painting techniques, a tube of acrylic will let you experiment with both – you can use the paint straight from the tube like oils, or thinned with water or a medium and used like watercolours. If you use acrylics as watercolours you have the following benefits:

BENEFITS OF ACRYLIC PAINT USED AS WATERCOLOUR

✓ Acrylic paints are environmentally friendly and are available in a great variety of colours.

✓ Acrylics can be diluted with water, enabling the finished watercolour to be indistinguishable from a traditional watercolour painting.

✓ When drying, acrylic paint dries no faster than traditional watercolour.

✓ Acrylic watercolours do not require special techniques as they are water based, requiring the same techniques and brushes as used for the painting of traditional watercolours. In fact the two media can be combined.

✓ Acrylics are much better value. The traditional watercolour tube contains 5ml of paint, whereas for a similar cost a 59ml tube of artists' quality acrylic can be purchased.

✓ Acrylic paints used as watercolours can be removed with a tissue when wet, like traditional watercolours, but when dry, if mistakes have occurred, they can be over-painted without lifting the under-painting, as could occur with traditional watercolour.

✓ Acrylics do not yellow with age and unlike traditional watercolours, which can lose up to 30 per cent of

their colour value on drying, acrylic watercolours lose very little. I always tell my students that if watercolour looks right when it's wet, it's wrong, as it is important to apply the paint darker to allow for drying. When using acrylics the colour you brush on remains the same when dry.

✓ Acrylics are versatile. It is possible to work from light to dark, as recommended when painting with traditional watercolours, but you can also paint from dark to light.

✓ Colour harmony can be achieved more easily. Once acrylic paint is dry, coloured glazes can be applied (see page 20). By applying glazes all over the painting or to selected areas colour harmony can be restored.

✓ Glazing techniques with acrylics can be a great asset to the beginner. A traditional watercolour sky, for example, must be painted in three to five minutes to avoid hard edges occurring – using acrylic paints you can spend as much time as you like painting your sky (see page 36).

✓ With acrylic paints it is easier to add detail, as subsequent layers of paint will not sink into the under-painting and become lost.

✓ Acrylics are particularly suited to transparent techniques. Any number of thin washes can be superimposed without muddying the colour. This means that intricate effects and textures can be created without loss of brilliance.

THE SECRETS OF WATERCOLOUR PAINTING

Know how wet the paint on the brush is in relation to the wetness or dryness of the under-painting.

Get the timing right to avoid hard edges. If you apply wet paint over an under-painting that is more than one-third dry you will create hard edges.

Use the largest brush possible in relation to the size of the element you are painting.

Use a light touch of the brush and the minimum number of brushstrokes to ensure freshness in your painting.

PAINTING ACRYLICS ON CANVAS

Beginners may find acrylic watercolour a challenge at first as it is a moving medium and it can be difficult to control the paint flow. Painting on canvas or board using acrylic paints and oil painting techniques, where the paint doesn't run, may suit you better. The texture and effects are very similar to oils, but there are other advantages:

- The main difference between acrylics and oil paints is the drying time. Oils allow more time to blend colours, but this slow-drying property of oil paint can impede the progress of the painting, preventing the artist from working quickly.
- When applying several colours in oils while each layer is wet it is easy to end up with mud. With acrylics, each layer will become tacky in minutes, allowing several layers to be applied, maintaining brilliance.
- Oil paints dry from the surface through to the support, which takes a considerable time; acrylic paints dry consistently throughout, reducing the varnishing time. Oils on canvas can take up to nine months to dry before they can be varnished. Acrylics on canvas can usually be varnished after three to six days, depending on the thickness of the paint.
- If you need to slow the drying time of acrylics, a retarder is available to mix with the paint. For me, however, it is the fast drying that is one of acrylic's main attractions, as when I am working outdoors on canvas it will become tacky on completion, allowing easy transportation home.

- Acrylic paints don't yellow, crack or age, appearing to be more stable than oils.
- With oil painting the rule of 'fat over lean' applies, where more medium has to be applied to each layer to avoid cracking. Due to acrylic's more flexible nature and consistent drying time between colour applications, 'fat over lean' doesn't apply.
- Acrylic paints can be kept moist on the palette by occasionally spraying them with a fine mist of water. Stay-wet palettes are also available to keep the paint moist (see page 14).
- Brushes must always be kept moist (keep them in a water pot when not in use) to prevent the paint from drying and ruining them.
- Brushes loaded with acrylic paint can easily be washed (see page 14), unlike brushes loaded with oil paint, which require a solvent to clean them.
- When painting on canvas or MDF board, acrylic paints are fairly fast-drying, have no odour and do not require spirits for thinning.

THE SECRETS OF PAINTING ON CANVAS

Your brush should be moist, not wet. If your under-painting is too wet, succeeding layers of paint will skid over the surface.

Use large brushes to cover large areas on the canvas.

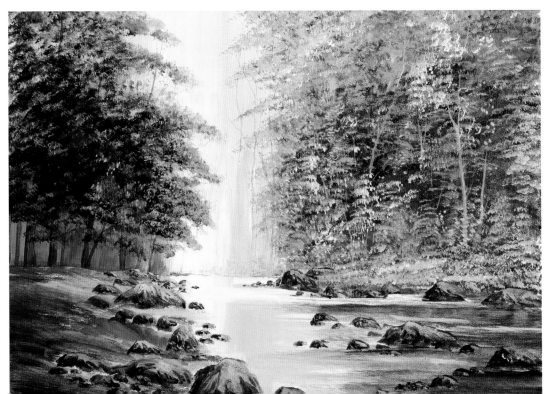

'Peace and Tranquillity' (Acrylic on canvas)

How to Use this Book

I have written this book with the aim of showing you how easy it can be to paint a landscape in a weekend. The first part introduces the basics, from materials to advice on building up your painting and how to get to grips with colours and glazes, together with some general tips on drawing figures and animals. The second part is where you put brush to paper, with projects in watercolour or on canvas that can be completed over the course of a weekend.

Painting an element of the landscape, such as clouds, is broken down into simple steps for you to follow and practise.

SATURDAY EXERCISES

The Saturday Exercises introduce different landscape features and are aimed at providing practice in painting the individual elements, in watercolour or on canvas, which will then be brought together in the Sunday Painting.

Techniques and principles such as perspective are explained, with illustrations that help to show how to achieve painterly effects using colour values and composition.

SUNDAY PAINTING

The techniques that you have practised on Saturday are all brought together in the Sunday Painting. I will guide you through each step in the painting process, showing you which brush to use and the colour combinations required, so that you have a complete landscape to show at the end of the day.

Each stage of the painting is shown, from blocking in the sky to adding clouds, trees and foreground features, drawing on the practice from the Saturday Exercises.

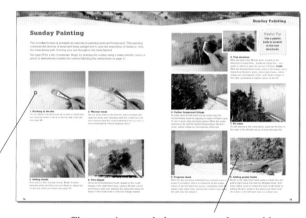

Close-up images help you to understand how to apply the paint and build the painting.

Gallery exercises:

These are included at the end of some projects to provide you with more ideas. All the tips and key considerations in the composition or style of the painting are given, together with a list of the colours and brushes used.

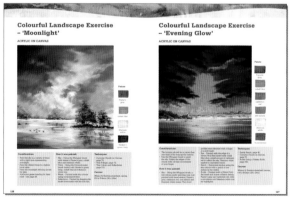

Colourful exercises:

These are included at the end of the book to give you the opportunity to use colour effectively to convey mood in your paintings and create more contemporary landscapes.

How to Transfer an Outline Drawing

To help you get started, use this technique to transfer the outline of the completed Sunday Painting. This is not meant to be a substitute for learning to draw and should only be used until, with experience, you become competent at drawing.

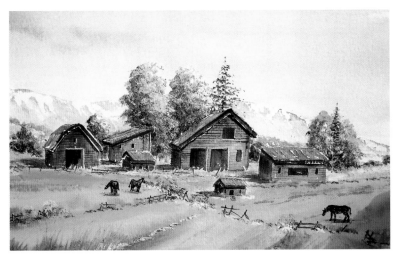

Take a black-and-white photocopy of the finished painting. You should find that there are distinct lights and darks in the photocopy – if this were not the case the painting's tonal values would be inadequate. The relationship between the lights and darks in a painting is of paramount importance.

The completed painting, given at the beginning of each project.

You will make lots of mistakes – all artists do, it is part of the learning process. The important thing is to learn from your mistakes and attempt to avoid them in your next painting.

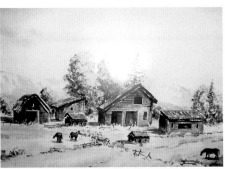

1. Take a black-and-white photocopy of the painting, enlarged to the required size. See 'You will need' for the size of paper or canvas for each project.

2. Using a soft pencil (6B), scribble across the back of the photocopy, making sure that you cover all the main elements of the image.

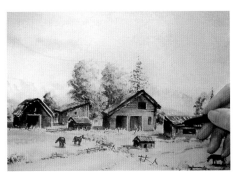

3. Position the photocopy over your support (paper or canvas) and secure the top with masking tape. Trace around the main outlines, using a burnisher or ballpoint pen.

4. Occasionally, lift up the photocopy from the bottom to ensure the outline has been transferred to your support. If not, go over the lines again.

Materials

Walk into any art store and the choice of brushes, paints, papers and other pieces of kit can be bewildering. So that you can begin painting this weekend, I've recommended the materials you need and included a brief introduction to the best of what is available.

ACRYLIC PAINTS

I always use artists' quality paints, as they are more economical in the long run, being stronger in pigment. I have been painting with Liquitex Acrylic Colours for over 30 years and have always found them to be consistent and strong in pigment, but if you are unable to get Liquitex products you can substitute them with other good quality brands instead. Liquitex offers artists four different consistencies:

- **BASICS**
 A less expensive paint intended for art students or those who want to cover large areas at low cost.
- **SOFT BODY**
 This was the original medium-viscosity paint formulation introduced in 1956. It has a smooth and creamy consistency, not as thick as Heavy Body.
- **HEAVY BODY**
 A high-viscosity paint with a thicker consistency for use with brushes or knives. The high pigment levels produce rich, brilliant, permanent colour.
- **SUPER HEAVY BODY**
 Offers superior shape retention. Used for palette knife work and traditional impasto work on canvas or panel.

Recommended paint

This book is about getting you started on the right road, and to avoid any confusion and save you from purchasing lots of different paints I have used HEAVY BODY paint throughout,

whether painting as a watercolourist on watercolour paper or using oil painting techniques on canvas. There is a school of thought that suggests that when learning you should purchase cheap brushes, cheap paints and cheap paper. My recommendation is, don't. It can be very frustrating when your brushes don't work as they should, because either the hair is too stiff or they don't hold sufficient paint; your watercolour paper has no texture and won't allow the paint to be absorbed; and your cheaper paints lack pigment content. My advice is to purchase the best materials you can afford and avoid unnecessary frustrations.

All of the paints, brushes, papers and canvases used in this book, apart from my special aids, are made by ColArt Fine Art & Graphics and are readily available from Winsor & Newton and Liquitex stockists.

DON'T ACRYLICS DRY TOO QUICKLY?

You may have been told that acrylics dry out too quickly and will ruin your brushes. However, when you use them as a watercolourist they don't dry any more quickly than traditional watercolours. When used to paint on canvas, yes, they do dry faster than oils, but that's their advantage. Keep your paint brushes in a water pot so that they don't dry out, and keep your palette moist to avoid any potential problems.

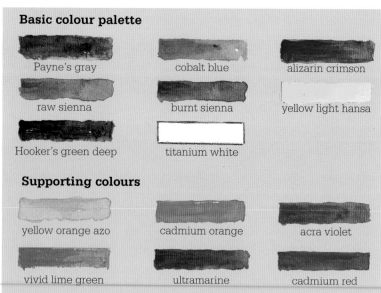

Basic colour palette

Payne's gray — cobalt blue — alizarin crimson

raw sienna — burnt sienna — yellow light hansa

Hooker's green deep — titanium white

Supporting colours

yellow orange azo — cadmium orange — acra violet

vivid lime green — ultramarine — cadmium red

Once you have learned the techniques and your confidence has grown, you may wish to begin experimenting with other consistencies, mediums, gels and pastes on offer. But for now, erase them from your memory and concentrate on using Heavy Body, which allows you to apply paint thinly or thickly, on both watercolour paper and canvas.

CHOOSING YOUR PAINT COLOURS

The choice of colours is personal to the artist but you won't go far wrong if you begin with my basic colour palette (below) from which you can mix an amazing range of colours for landscapes – woodland greens and browns, sunset oranges, sky blues and purples. With experience you will be able to mix virtually any colour tint with the three primary colours – red, yellow and blue – but most professional artists will use between eight and twelve colours in a painting.

Most landscapes can be painted using my basic palette, although some call for additional colours, and I use these supporting colours for rich late-summer foliage on trees and foreground grasses to make them sparkle with colour. When painting in hotter climes, I sometimes substitute ultramarine for cobalt blue in the sky, and acra violet is a useful colour when mixed with cobalt blue to paint backgrounds and variation in sky colours.

Mixing tints

You can adjust the strength of the colour in different ways, depending on how you choose to work. When painting on watercolour paper the colours are thinned with water. When painting on canvas the colours are tinted by mixing with titanium white.

Laying out your colours

Every artist will arrange their colours on the palette to suit their preference. My layout is simple. Clockwise, I start by positioning Payne's gray, cobalt blue and alizarin crimson; these are my sky colours. I follow these with raw sienna and burnt sienna; these are my earth colours. My mixers are yellow light hansa and Hooker's green deep.

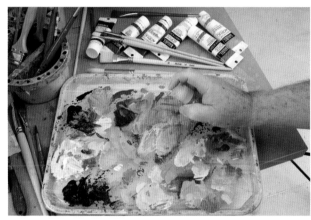

MY PALETTE

This is the palette I used when painting the landscapes in this book. As long as the brush is going into the paint, the paint will not dry out. If I haven't used a particular colour for a while or I want a break, I spray that colour or the whole palette with clean water to keep the paints wet until I use them again.

WORKING INDOORS

People work in all types of places, from a garden shed to a caravan. You don't need a large space, but it is important to have an area that is comfortable, well lit and ventilated and offers you peace and quiet, allowing you to focus on your artwork.

My work area is well lit during the day with natural light; in wintertime, when the light quickly recedes, I use 'Daylight' bulbs that aim to replicate the natural light and help to reproduce the colours you find when working in good daylight. I use a wonderful work-station supplied by Phantasm Easels, which is very stable and easy to adjust, together with a comfortable, height-adjustable swivel chair. A large palette and water pots are always close at hand. However, when the weather is good, I prefer to work outdoors (see page 30).

Brushes

Your set of brushes is an essential tool for applying paint to paper or canvas, helping you to achieve effects and textures that bring the landscape to life. In addition to the basic sets, I have also developed some special aids specifically for landscape painting.

Brushes are available in different sizes, shapes and hairs. Natural hairs hold more paint than synthetic fibres. Brushes such as the Winsor & Newton Sceptre Gold series are a good, economically priced compromise, being a mix of natural hair and synthetic fibres, but there are many other good quality brands that can also be used. I cannot overemphasize the importance of using quality brushes – don't purchase inferior ones.

Cleaning your brushes

To keep your brushes in top condition, never allow the paint to dry on the brushes – keep them in a water pot as you work. If you accidentally leave a paint-loaded brush out of the water pot, after about 30 minutes the paint will have dried on the brush and become difficult to remove. To clean your brushes after use, place a little washing-up liquid in the palm of your hand, rinse the brush under warm running water to remove surplus paint and mix with the washing-up liquid in your palm until the paint has been removed. Finally, rinse the brush with clean water, dry the hairs with a tissue and smooth the hairs into the natural shape of the brush before laying it flat to dry. Don't store your brushes with their points up until they are perfectly dry, as any water left in the ferrule will seep down and warp the wooden handle.

Brush shapes

- **FAN**
 These brushes produce delicate, feathery lines and are used for blending.
- **FLAT**
 This is good for laying large areas of colour and for painting rocks and buildings.
- **FILBERT**
 Shaped to a curved tip for tapered brushstrokes.
- **HAKE**
 A soft-haired wash brush for painting skies and large washes.
- **RIGGER**
 A thin brush that is used for painting fine lines and details.
- **ROUND**
 The most common shape, and a good all-rounder for applying paint and adding details.

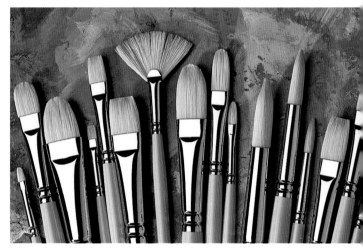

BRUSHES FOR WORKING ON CANVAS
I use Artists' hog hair brushes when painting on canvas, with a range of flats from 15–25mm (½–1 in) wide, a range of round brushes from 10–15mm (¼–½ in), a fan brush and a 15mm (½ in) filbert. These are excellent quality brushes that I can use to paint when time isn't so important.

PALETTES

The palette is the surface on which you lay your paint straight from the tube, then mix and blend your colours and washes. As acrylics can dry out quickly, it is important to keep the paint moist (I use an atomizer spray) or use a damp palette. As seen on page 13, I have used a white plastic tray, covered with cling film (plastic wrap) as my palette for the projects in this book. I don't like cleaning palettes. When I have completed the painting session I simply remove the cling film and re-cover the palette for the next day. Winsor & Newton market a special palette for use with acrylics, together with disposable palettes.

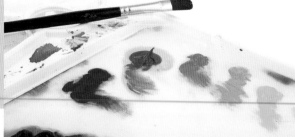

STAY-WET PALETTE
Compact stay-wet palettes are widely available and keep acrylics wet for several days.

SPECIAL AIDS

When I demonstrate painting techniques to art societies or at shows and events, I paint two complete landscapes in two hours. It is therefore necessary for me to use larger brushes to cover the canvas quickly and to supplement standard brushes with specially designed brushes to simplify the speedy painting of tree foliage and foregrounds. Drawing on my experience, I have developed my own special range of brushes and materials specifically for the landscape artist. For example, the 'Whopper' is ideal for large areas such as skies, and the 'Unique' brushes are designed for tree foliage and foreground bushes. There is also the 'Sky and Texture' brush and the 'Wonder knife' for texture. I have used these Special Aids (see below) in the exercises and projects throughout this book. For more information visit my website, www.keithfenwick.co.uk.

BRUSHES FOR WATERCOLOUR PAINTINGS
Winsor & Newton's Sceptre Gold brushes are a sable/synthetic hair mix. I use a Size 14 round for moving paint, background trees and so on, and the side of the brush for applying paint. A rigger brush is used for fine lines such as tree branches, and I use a 20mm (¾in) flat for painting buildings, rocks, roofs and so on.

'Derwentwater': one of my 'Unique' tree foliage and foreground brushes, it has a round end and is used for stippling foliage, wild flowers and foregrounds. Alternatively a round ended hog hair brush can be used.

'Whopper' brush: for painting on canvas, to cover large areas such as sky, background trees, river banks and so on, I use this special 40mm (1½in) wide brush with lovely soft, flexible hair.

'Stippler': 25mm (1in) wide, for stippling foregrounds, trees, foliage and grasses.

'Ullswater': a 'Unique' tree foliage and foreground brush, it has an angled end for painting details such as bluebell woods, ivy on trees, fir trees, foregrounds – whenever I require more control of paint deposits. Alternatively an angled hog hair brush can be used.

20mm (¾in) mop brush: I occasionally use this for skies and snow-covered land areas.

Water-soluble brown crayon: I always draw with a dark brown crayon. As paint is applied the lines wash out.

Water-soluble white crayon: this is ideal for correcting errors, such as paint splashes, adding highlights or softening edges.

'Sky and Texture' brush: 40mm (1½in) hake with a chisel edge for watercolour skies and foregrounds.

'Wonder knife': a special shaped palette knife for moving paint. It is ideal for creating rocks, mountains and buildings.

MY SPECIAL LANDSCAPE AIDS I have developed this selection of brushes and materials specifically to help with landscape painting. These brushes are widely available from my website.

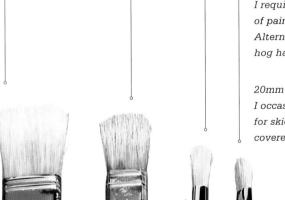
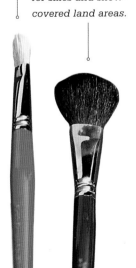
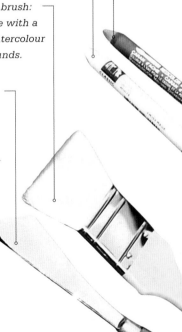

Supports and Extras

A support is any surface that you paint on, such as paper, canvas, board, wood and dry plaster. The acrylic artist has a wide range of supports to choose from, but for the purposes of this book and for simplicity, I have used paper and canvas.

CANVASES

A canvas is a ready-made textured surface that holds the paint. It is available on the roll for larger paintings or pre-stretched on a frame or board in different qualities. These are available in a great variety of sizes and shapes to suit traditional landscape formats, or longer widths for seascapes and cityscapes. They are ideal when painting outdoors as they are light and easy to transport. The step-by-step paintings in this book have been painted on canvas boards.

STRETCHED CANVASES
Many leading brands produce stretched canvases and canvas boards suitable for acrylics, with both standard and deep edges.

PAPER

For watercolour painting, paper can be purchased in many different forms, sizes, textures and weights. It is available as single sheets, or in gummed pads, spiral-bound pads and in blocks, where the paper is glued all around except for an area at one corner so that each sheet can be lifted and separated from the block. For the projects, attach a sheet of paper to a board using strips of masking tape all round the edges.

Basically there are four kinds of paper surface:
- **HP** (Hot Pressed) has a smooth surface and is mainly for drawing, calligraphy and pen and wash work.
- **CP/NOT** (Cold Pressed or Not Hot Pressed) has a slight texture on the surface (called tooth) and is used for traditional watercolour paintings.
- **ROUGH** paper has a more pronounced texture, which is wonderful for controlling the flow of large washes such as skies, for painting tree foliage and creating sparkle on water. This is my preferred paper surface and has been used for all the watercolour paintings in this book. A rough paper provides a good surface to brush against and it allows the artist to create interesting effects. For the beginner who hasn't yet learned to control the run of the paint, it is ideal, as it helps to control the flow.
- **EXTRA ROUGH** is used where a more pronounced texture is desirable, perhaps for painting seascapes with rough-textured rocks, or waterfalls.

Paper is purchased in different weights (expressed either as the gram weight of 1sq m of a single sheet, or as the pound weight of 500 sheets size 76 x 56cm/30 x 22in):
- **190GSM (90LB)** is thin and light in weight and, unless stretched beforehand, it cockles very easily when washes are applied. I don't recommend this weight. Any paper weighing between 190gsm (90lb) and 300gsm (140lb) needs to be stretched to prevent it cockling. To stretch paper, immerse it in water for a few minutes, hold it up by the corner to drain off surplus water and lay it flat on a board. Secure all round using gummed tape and leave to dry overnight. The dry paper will be as tight as a drum and ready for painting.
- **300GSM (140LB)** paper doesn't need stretching unless heavy washes are going to be applied.
- **425GSM (200LB) OR 630GSM (300LB)** are my preference. All the watercolour paintings in this book have been painted on 630gsm (300lb) paper.

MEDIUMS, GELS AND PASTES

As a beginner you don't need to concern yourself with the very many 'extras' available to the artist. I have listed a few here simply for your information: once you have learned to paint, you can experiment with the different effects. Art stockists provide a wide range of pamphlets describing their properties.

Mediums:
- Gloss and matt medium and varnish
- Slow dry blending medium
- Glazing medium
- Fabric medium
- Modelling paste
- Flow enhancer
- Retarder

Texture gels:
- Black lava
- Blended fibres
- Glass beads
- Natural sand
- Resin sand
- Opaque flakes
- Iridescent/Pearlescent mediums
- Coloured gessos for surface preparation.

ADDITIONAL ITEMS

I use the following items to support my painting kit:
- **MASKING TAPE** 20mm (¾in) wide, to control paint flow, mask areas and fasten the paper to the board.

- **PAINTING BOARD** To fasten paper to; the board should be 50mm (2in) larger all round than your painting.
- **TISSUES** Use absorbent tissues or toilet roll (bathroom tissue) for lifting paint, applying textures and cleaning palettes.
- **KITCHEN ROLL (KITCHEN PAPER)** For cleaning brushes when painting on canvas.
- **MASKING FLUID** For applying to watercolour paper to preserve the white of the paper.
- **ERASER** Use a hard eraser to remove masking fluid.
- **ATOMIZER BOTTLE** For spraying paper with clean water and for spraying over your palette to prevent the paint drying.
- **SPONGE** Natural sponges are useful for removing colour, creating tree foliage, adding texture on rocks, rendering bluebell woods, and so on.
- **WATER-SOLUBLE CRAYONS** Used for drawing outlines, correcting mistakes and adding highlights. As paint is applied, the lines are washed out.
- **SAUCERS** For mixing colours for large washes and pouring paint.
- **HAIRDRYER** Used for speeding up drying time of the paint between stages.
- **EASEL** For painting both indoors and outdoors. I have a selection of lightweight easels for outdoors and a work-station for indoor work.
- **CHAIR** A comfortable folding chair for outdoor work.
- **HAVERSACK** To carry art materials when working outdoors. I use a combined haversack and stool.

PAPER SURFACE
Here you can see the different effects of the various papers when paint is applied. From left to right: Hot Pressed (HP), where the mark is smooth and solid, Cold Pressed (CP/NOT), where the paint shows a little texture and separation, and Rough, which shows a textured mark. The Rough paper shows the lovely effect you can obtain when brushing on colour.

ACRYLIC MEDIUMS
Liquitex produce a wide range of mediums, gels and pastes that will allow you to experiment.

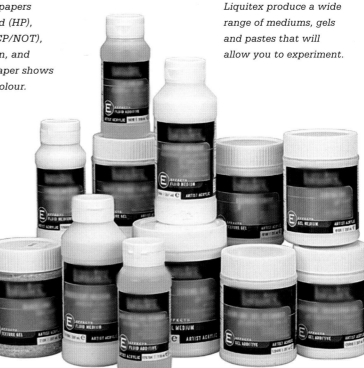

Colour Mixing

Many books have been written about colour mixing, and colour has fascinated artists for many generations. There is no substitute for practical experience, and an afternoon spent mixing colours and tints will help you to understand how to create a whole spectrum of landscape colours from just a few deposits of paint on your palette.

GENERAL PRINCIPLES

The three primary paint colours are red, yellow and blue. If similar quantities of each of these three colours are mixed together the resulting mix will be black, as shown in the colour circle below. Blue and yellow mixed together will produce green; red and yellow will produce orange; and red and blue will produce violet. These mixtures are known as secondary colours. Tertiary colours are created by mixing one of the primary colour with a secondary colour.

By mixing the three primary colours in the above combinations with varying levels of water, a huge variety of hues can be produced. Of course, a wide range of colours can be purchased but there is no substitute for experimenting to discover the range of colours and values you can produce yourself. My basic colour palette (see page 13) includes the primaries: alizarin crimson, cobalt blue and yellow light hansa. The additional colours help to extend the mixes that I can achieve, using white for tints when working on canvas.

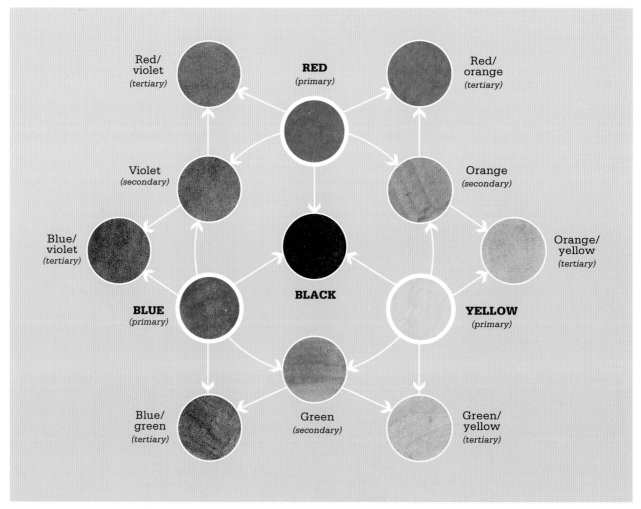

COLOUR CIRCLE
The colour circle shows the primary colours – red, yellow and blue – and their secondary and tertiary mixes.

MAKING TINTS AND SHADES

Common sense dictates that if you want to mix a dark tone you add a little light colour to a lot of dark colour. To mix a light colour, place more of the light colour on the palette and add a small amount of the dark colour.

MIXING GREYS

If you mix approximately 20 per cent of any colour on your palette with approximately 80 per cent Payne's gray, you will obtain a wide range of greys, suitable for buildings, mountains, rocks, shadows and so on.

MIXING GREENS

With four colours – Payne's gray, cobalt blue, yellow light hansa, raw sienna – you can mix a vast range of greens that are ideal for the landscape painter.

MIXING EXERCISES

The following two exercises can be mixed on both watercolour paper and canvas, providing useful practice in colour mixing. Working in a clockwise direction, start with the first colour at 12 o'clock, then add the next colour to it, blending them together and working the resulting mix into the subsequent colours, as you work around the 'clock'.

MIXING GREENS

Starting at 12 o'clock: Payne's gray, Hooker's green deep, Hooker's green deep and yellow light hansa, more yellow light hansa, add some raw sienna and finally at 10 o'clock some yellow light hansa.

MIXING WARM COLOURS

Commencing at 12 o'clock: cadmium red, raw sienna, burnt sienna, yellow orange azo, yellow orange azo and cadmium red, cadmium red and yellow light hansa, add some burnt umber to the preceding mix at 10 o'clock.

Glazing Techniques

A glaze is a transparent layer of colour applied over another layer of paint once it has dried. It has the effect of modifying the underlying colour, adding a sense of depth and luminosity over the painting as a whole. You can use a glaze to add harmony, to change the colour or contrast, or to highlight particular areas.

WHAT IS A GLAZE?

Glazes are made by mixing a small quantity of paint with a larger quantity of water – when painting with watercolour – or by mixing with a glazing medium when working on canvas. The level of transparency achieved depends on the relationship between the amounts of paint and water or glazing medium used in the mix, as well as the particular properties of the chosen colour.

Acrylics are perfect for glazing techniques. With traditional watercolour, the glaze can soak into the under-painting if you don't work quickly and dry the glaze immediately with a hairdryer. Unless you have a light touch and use a very soft brush when applying glazes over a traditional watercolour painting, there is a danger of lifting the under-painting. This can't happen with a watercolour artwork painted with acrylics, because once the under-painting has dried, the paint cannot be lifted when brushing over an acrylic glaze.

WHY USE A GLAZE?

Glazing can produce exciting atmospheric effects and can be applied as a flat wash (a large area of colour), a graduated wash of a single colour (a wash that changes in tone from dark to light) or a graduated wash using several colours. A glaze can assist you in achieving the correct tonal values (value pattern), contrast, variation and colour harmony in a painting. For example, consider a case where you have painted an expanse of green grass and your green is far too bright and garish. All you have to do is to over-paint with a pale blue glaze and the balance and colour harmony will be restored.

> You can relax in the knowledge that if you don't get the colour harmony correct first time, the application of a glaze or several glazes can restore the balance.

Adding sparkle to your landscapes

- Applying a pale raw sienna glaze over a foreground can add sparkle to your painting.
- A glaze applied over any areas in between tree foliage can add sparkle to the foliage.
- Glazes can be applied selectively to parts of your painting to improve the relationship between the lights and darks – a most important design concept in your painting.
- A glaze can be applied over a whole painting: this will restore colour harmony by adding a single colour to every other colour in your painting.
- A glaze can be applied to a large area, such as the sky, or to smaller areas such as stonework and buildings.
- When areas of the painting look too cool, warm-coloured glazes will restore sparkle.
- When areas of the painting appear too colourful or bright, a cool-coloured glaze will restore the balance.

MIXING A GLAZE
Thin your chosen colour by adding water to the paint. Test the density of the glaze on a separate piece of paper before applying it to your painting.

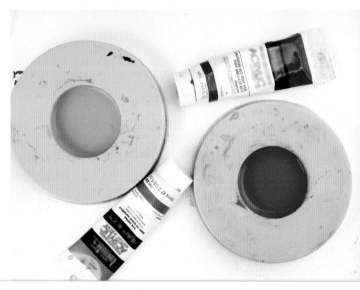

APPLYING A GLAZE

My approach is to look at a painting over a few days and if I consider it necessary, apply glazes to improve the painting prior to framing. It is a good idea to test your mixed glaze on a piece of scrap watercolour paper, to determine whether it will have the required effect, before applying it.

Use a soft-haired brush, such as a hake or my Sky and Texture brush, to apply the glaze in gentle strokes. When applying a glaze your board should be tilted at a low angle of approximately 10 degrees, to encourage the glaze to run slowly down the painting. Remove the waste pool at the bottom, using a thirsty brush or piece of absorbent tissue.

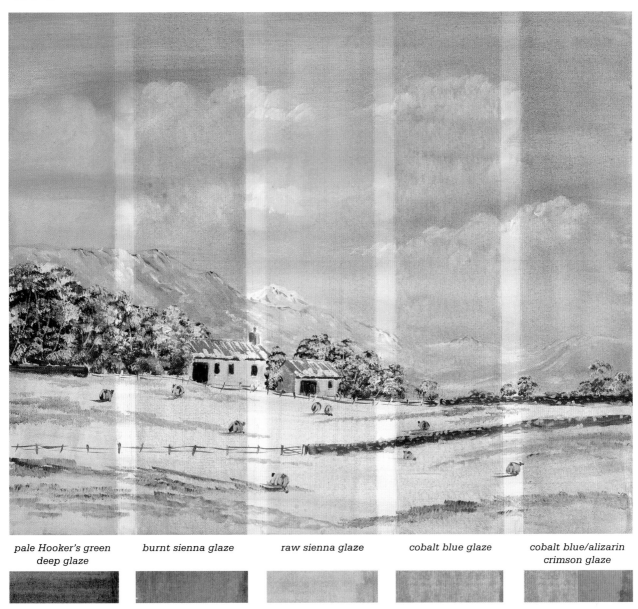

| pale Hooker's green deep glaze | burnt sienna glaze | raw sienna glaze | cobalt blue glaze | cobalt blue/alizarin crimson glaze |

COLOURED GLAZES

Experiment with your glazes – they can transform your landscapes. To demonstrate the effect coloured glazes can have on your artworks, I have divided this 20-minute 'doodle' into five areas and glazed each with a different colour.

Keep glazes light in tone: you can always apply further glazes to build up the desired value.

Glazing Techniques

GLAZING EFFECTS

I'm afraid I have a wicked sense of humour: when I demonstrate acrylics to art societies and commercial organizations I often begin by painting a snow scene, and when they break for refreshments I change the snow scene by applying glazes, turning the painting into a summer or fall scene. They return to the room and look all puzzled until I explain the versatility of acrylic glazes. There's always someone who asks if I can change it back – no, no, no!

So, if you paint yourself a snow scene and hang it on the wall, and after a year you become tired of it, just take it down, glaze it with warm colours – raw sienna, burnt sienna, cadmium orange – and you have yourself a new painting. On these pages, I have glazed two paintings to demonstrate how you can change the feel of a painting with glazes.

SNOW SCENE TO SUMMER MEADOW

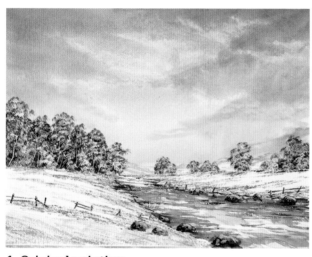

1. Original painting
I painted a snow scene using cool colours, leaving the paper unpainted in places to represent snow-covered land. The effect is of a cold, winter day.

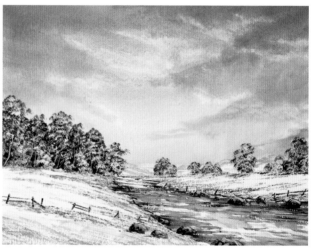

2. Applying a blue glaze
I then mixed a cobalt blue glaze in the top of my water pot (you can use a saucer) and applied it over the whole of the sky area and in the water with a hake brush.

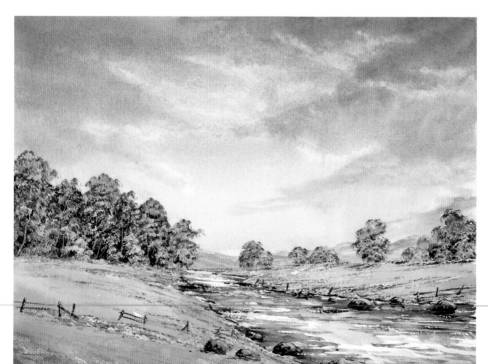

3. Applying a green glaze
Finally, I applied a soft green made from a mix of vivid lime green and raw sienna, brushing it over the tree foliage, distant hills and river banks. The resulting effect is of a bright, warm, early summer day.

WALK ON THE BEACH

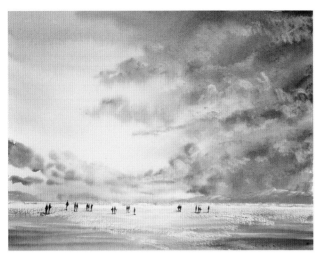

1. Original painting
I painted the original image in cool colours, giving the impression of a breezy, chilly day.

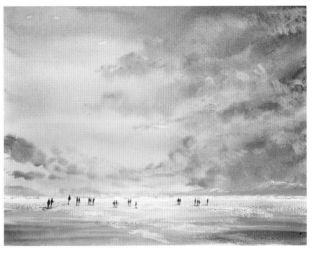

2. Applying a raw sienna glaze
I then mixed two separate glazes from raw sienna and cadmium red deep. I initially applied the raw sienna glaze over the whole of the painting, working from top to bottom. The paint was allowed to dry completely (I used a hairdryer to speed up the drying process).

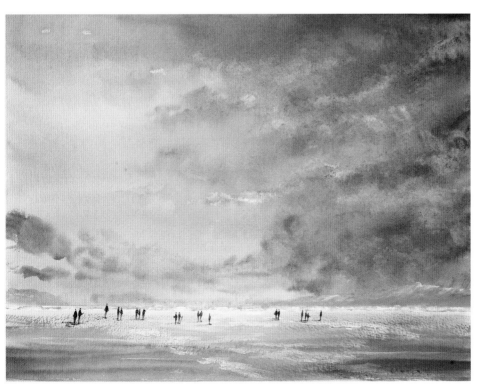

3. Applying a cadmium red glaze
The final stage was to wet the dry painting all over with clean water and brush in the cadmium red deep glaze to selected areas of the clouds and beach. You have to have confidence to apply two completely different coloured glazes like this but the result is well worth it. The final image looks hot and sultry.

Building up the Painting – the Jigsaw Approach

When the beginner or leisure painter sees a finished painting their first response is often, 'I can't paint that!' Well, I say you can if you really want to. Although the painting may look daunting, I want you to think of it as a *jigsaw*, placing each of the pieces together to make a unified whole: after all, that's how the landscape is painted. You will see this in the step-by-step exercises.

One area is painted at a time, linking them together until the painting is complete. The basic sequence begins with an outline drawing of the composition. The sky is painted first, followed by the distant features – in this example the mountain structures. These are followed by the mountains in the middle distance. The next stage is to paint the distant and middle distant trees, followed by the foreground land. The water is painted last, with the rocks added to create interest. After the initial under-painting has been completed, the details and highlights are added to produce the final painting. Once you have completed a few of the Sunday Paintings, any doubts you had will quickly be dispelled – breaking the painting down in this way will make it achievable. Start with a positive state of mind – you can do it, with practice.

Remember, 'Quitters never achieve – achievers never quit!' You can do it if you have the desire.

When learning to paint, do not attempt too large a painting or your mistakes will be bigger. With confidence, you can increase the size of your paintings. Work to the sizes recommended in the projects.

1. Sky painted first

2. Mountains and distant features

3. Snow crevices

4. Trees and land

5. Water

6. Rocks

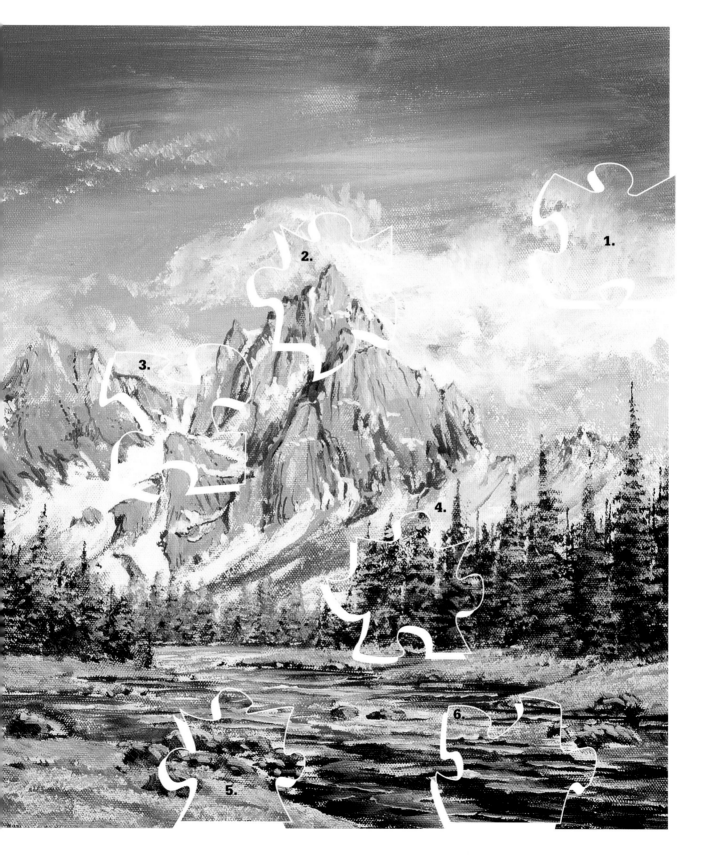

Adding Life to the Landscape

Adding distant figures or wildlife can transform a painting. Here, I'm going to show you some quick and simple techniques for rendering impressions of people, animals and birds. These are not intended to be detailed representations, just basic impressions that can be included in the middle or distant areas of your landscape – making it more interesting and pleasing to the viewer. You will get further practice in the Saturday Exercises.

FIGURES

Ramblers, farmers, fishermen, day trippers – all types of people populate the landscape, and their inclusion, even as dots of colour in the distance, adds life and interest to a scene. Avoid the usual pitfalls: painting the heads too big; making the figures too wide and stumpy, rather than thin and tall. Don't attempt to paint feet on such small figures.

PAINTING PEOPLE

1. Paint the shape of a lemon.

2. Add a small lemon for the head.

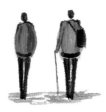

3. Add legs and make the figures your own by painting a couple holding hands or individuals carrying a stick, bag or haversack.

To paint a particular stance, such as running, put yourself in that pose and observe the position of your arms, the angles of your legs or the slope of your body and paint accordingly.

> ### Useful Tip
> When painting lots of figures, as in a beach or street scene, remember, only impressions are needed.

SWANS

These regal birds make great focal points in a waterscape and can be rendered relatively easily by breaking their shape down into separate elements. When including birds in your landscape, they can be drawn first and masked out using masking fluid prior to over-painting the landscape. When dry, the masking can be removed to restore the white of the paper. The swan shapes can then be painted in. Personally, I prefer to avoid masking fluid and to paint the swans in when the painting is finished, using some acrylic white paint.

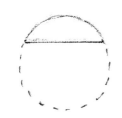

1. Paint the top of a circle for the body.

2. Add the wings and tail feathers.

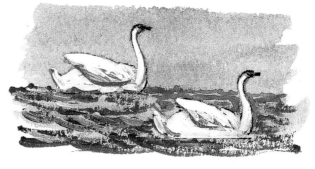

3. Add the neck and head. Use a rigger brush and add a little burnt umber and titanium white mix to add depth to the wings and tail. A little yellow light hansa applied to the head provides realism, as does a touch of Payne's gray for the beak.

HORSES

These stately animals may seem a daunting prospect to the beginner, but follow my breakdown of their shape and you can include a convincing impression in your scene.

STANDING HORSE

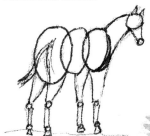

1. Use circles to represent the shape of the body, head and leg joints.

2. With a Payne's gray, burnt umber and raw sienna mix, join the shapes together to create the impression of a standing horse.

TROTTING HORSE

1. Draw circles and join them together to achieve the horse's profile.

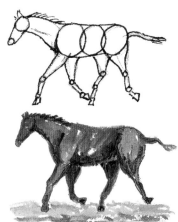

2. Here, I have added a little more burnt sienna to the mix (right) to create a richer colour.

GRAZING HORSE

1. Paint the shape of two keyholes to represent the body and legs, then add the neck, head and tail.

2. Using a rigger brush, paint the impression of a horse by adding a Payne's gray and burnt umber mix over a raw sienna under-painting.

SHEEP

Whenever I tell my audience that I'm going to paint impressions of sheep by painting 'horseshoes' their response is to laugh, but that's all you do. In their winter coat you won't see the animals' legs but in the summer when they have been clipped you will – there's one in each corner!

1. Paint your 'horseshoes' in different sizes, larger in the foreground and smaller in the distance, to achieve a sense of perspective.

2. Paint each body using a rigger brush loaded with a Payne's gray and burnt umber mix. If your sheep is looking to the left extend the horseshoe to the left and add a small triangle for the head, keeping the point of the triangle towards the ground. If looking to the right extend the body to the right and again add a triangle for the head.

3. When the paint is dry, use the rigger brush loaded with titanium white to paint their bodies, adding a little white dot on the end of each nose.

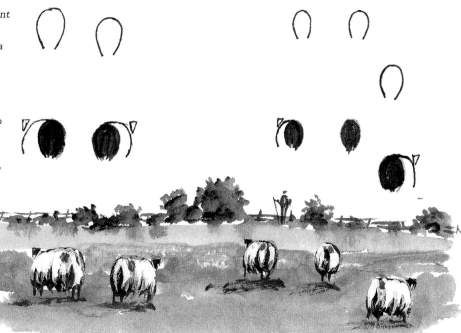

Adding Life to the Landscape

GEESE

Anyone can paint a bottle, and that's all you do to represent geese. A few impressions of geese flying over a lake or lagoon can add wonders to your artwork. Here, I have represented Brent geese, but if you painted them entirely with burnt umber they would still enhance your landscape. See page 126, where I have included such impressions in the painting 'Moonlight'.

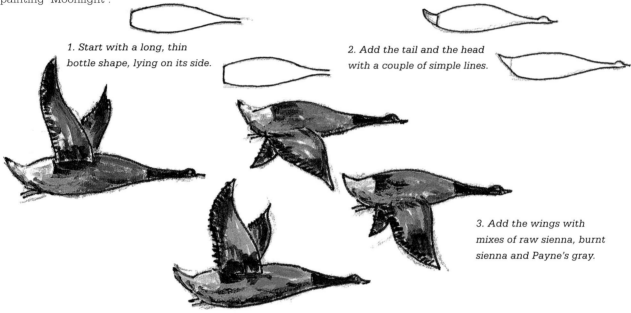

1. Start with a long, thin bottle shape, lying on its side.

2. Add the tail and the head with a couple of simple lines.

3. Add the wings with mixes of raw sienna, burnt sienna and Payne's gray.

COWS

A universal feature of the landscape, cows are ideal for adding interest, whether individually or in a herd.

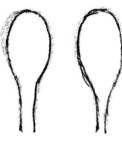

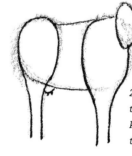

1. Paint two 'keyholes' for the front and back legs.

2. Add an ellipse for the head and join the keyholes up to create the body.

3. Add the ears and some colour and you have painted your impression of a cow. For a full face view simply overlap the keyholes, and for Texas Longhorns, paint them brown and add those imposing horns.

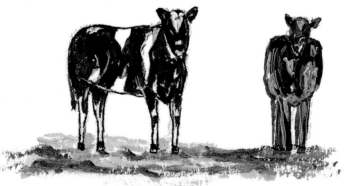

Considerations

- Ensure your figures, animals or birds are included as an integral part of your landscape – not just as an afterthought.
- Don't paint your figures in too much detail or paint the heads too small.
- Don't forget to paint shadows underneath your subjects to ground them in the landscape.
- Take advantage of counter-change: positioning a pale representation against a dark background and vice versa.
- Use transparent film to establish the size and position of your figures (see below).

POSITIONING IN THE LANDSCAPE

A useful tip for establishing the correct size and the ideal placement of your subjects before applying paint to your support, is to purchase an acetate sheet, or even a clear plastic wallet, from your local art shop or stationers. You could also use tracing paper.

Draw your figures, birds or animals on this transparent sheet, using a water-based felt-tip pen so that they can be washed off and the film used over and over again. You can lay the film over your painting and move it around to determine whether you have drawn your subjects to the correct size and where they should be placed. Use this tip for positioning figures on a beach, rocks in a river, or birds or animals in a landscape.

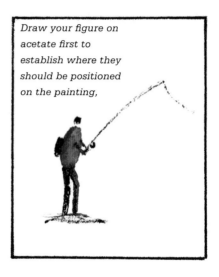

Draw your figure on acetate first to establish where they should be positioned on the painting,

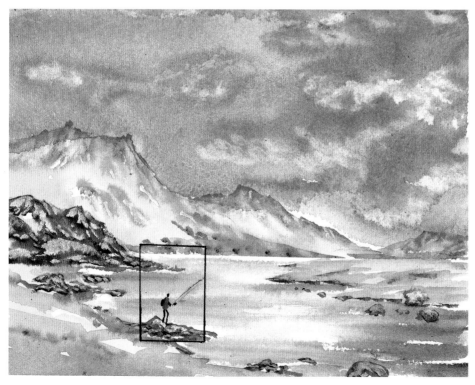

DISTANT FISHERMAN
The fisherman in this painting, was moved up and down the left-hand bank until the best position was chosen. If the film is turned over, the figure can also be moved along the right-hand bank.

Working Outdoors

To paint a landscape you need to experience the landscape, and this means setting yourself up on location, with everything you need to hand, a sturdy easel, a comfortable seat, a fine view and, hopefully, clement weather! Deciding what kit to take with you, how to choose your composition from the vast expanse on offer and making notes and sketches, are all part of the enjoyment of painting outdoors.

There's no substitute for working outdoors: the sounds, smells, light and colours all help to create a feeling of excitement. The opportunity to capture a particular landscape at a particular period in time never fails to stir my emotions. Listening to the sounds of birds singing, perhaps being accompanied by the local heron, swan or dipper, adds to the pleasure of the moment. The sound of running water splashing against or tumbling over rocks is so pleasing to the ear, providing a sense of peace and tranquillity that's a pleasure to experience.

TRAVELLING LIGHT

The equipment I carry when working outdoors really depends on how far from my car I have to walk to reach the area where I am going to paint. If I can park my car and jump over a wall to reach a river, perhaps a few yards away, then I can use any amount of equipment I wish. If I have to walk miles from my car I must travel very light and aim for comfort. Sketching and painting watercolours require fewer materials than painting on canvas and if I am walking considerable distances, there's less weight to carry and the finished paintings are easier to transport home than a wet canvas.

If I have to walk a long way, I may simply carry a haversack filled with my art materials (paints, palette, brushes, watercolour block, water pot) but no easel. I can usually find a rock somewhere to sit on, work with the block across my knees and lay an old towel on the grass on which to place my brushes, and I'm away.

- **Lightweight easel:** If I am not travelling too far, I like to work from a lightweight metal easel, which is telescopic and easy to set up, the leg lengths being adjustable to varying surface heights.
- **Haversack:** I carry my art materials in a combined haversack and chair.
- **Palette:** A disposable palette is useful on location.
- **Paints:** Tubes of paint need to be well protected.
- **Water pot:** I fill it up when I reach my destination.
- **4B pencil:** For sketching.
- **Water-soluble crayons:** I put a tin of ten in my pocket and they enable me to draw and sketch any view I come across with ease.

USING AN EASEL
Here I am sitting on a rock by the side of a lake, painting on an easel. My haversack is used as a stool to rest my palette and water pot on and I'm sitting on a walker's cushion (foam pad) to keep my rear end dry and comfortable.

CHOOSING THE BEST COMPOSITION

I think of composition as a means of arranging all the elements in a painting to the best effect so that unity is achieved. When visiting an area looking for a composition to paint, I follow a logical procedure. I may walk up and down a river bank for example, looking for exciting possibilities, such as an interesting group of trees, an unusual shape in the bank or a bend in the river with the possibility of a small waterfall or an interesting group of rocks. The viewfinder in my digital camera allows me to frame possible views and I am able to take various shots and compare the compositions.

The tranquillity of the scene, the sound of running water, the colours and flow patterns will all have stirred my emotions and I can't wait to set up and begin painting.

SKETCHING AND DRAWING

When I'm on my travels, I'm always on the lookout for interesting views to paint. I always carry a 4B pencil and a tin of water-soluble crayons, which are fantastic for sketching, drawing and painting. With the ten colours in the box I can create a colourful composition by drawing and washing out the colours. They never seem to wear out. I can use them dry, wash out areas, make marks on the paper and dip a wet brush into the colours to create various washes. I can take the colour directly off the crayons or dip them in water and draw or paint with them. The choice between sketching and drawing in

pencil or using crayons is personal to every artist. Crayons are quicker, as colour can be applied with the point, side or edge and then washed out and blended to cover large areas speedily.

SKETCHING OUTDOORS
Here, I am sketching in the woods, using a pencil and sketchpad to take down a view that has caught my eye.

FILMING FOR A TV SERIES
I'm sitting on a rock in the water painting a packhorse bridge and the fast flowing stream. My palette is clipped on to my telescopic metal easel and my chair is precariously balanced on a rock. The TV crew are around me. My feet are keeping cool in the water.

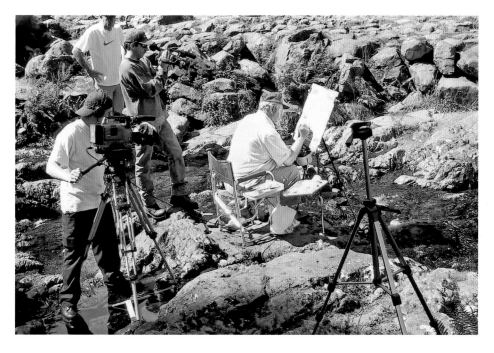

The Projects

The projects have been selected very carefully to demonstrate the versatility of acrylics, both on watercolour paper and on canvas. The aim is to provide you with two different approaches to help you decide which style suits you best.

Each project gives me the opportunity to show you a wide range of techniques that I have practised over many years of painting landscapes. You'll discover how to render skies, light on water, the effects of weather and the colours of the seasons, with tips and suggestions on how to apply paint, mix colours and use specific techniques to achieve different effects and textures. Hopefully, I will be able to save you many years of learning and help you to produce paintings that you will be proud to hang on your wall.

Many of the projects start by outlining the main elements of the painting. If you don't feel confident about your drawing skills, then simply follow the instructions on page 11 to transfer the outline of the painting to your paper or canvas.

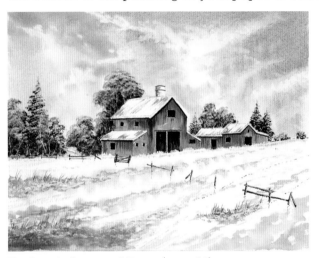

Project 1: Snow and Barns (page 34)

> Don't let anyone tell you that you won't be able to paint, because I say you can – it's just a matter of practising. Learn from your mistakes – I believe you can do it if you really want to.

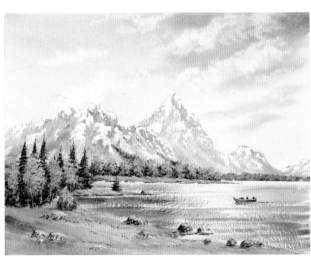

Project 3: Mountains and Lake (page 58)

Project 2: Sea and Beach (page 46)

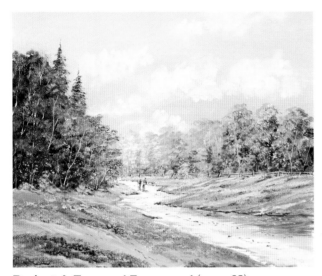

Project 4: Trees and Foreground (page 68)

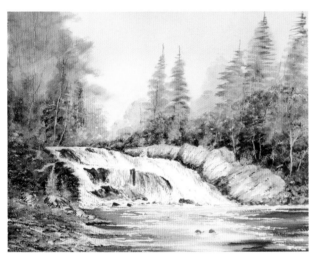

Project 5: Waterfall (page 80)

Project 6: Trees, Rocks and Running Water (page 90)

Project 7: Sky, Rocks and Sea (page 102)

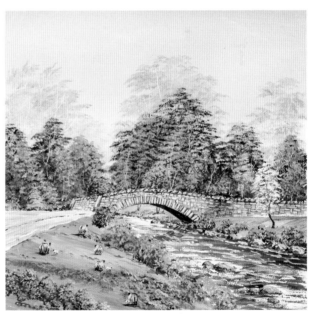

Project 8: Springtime (page 112)

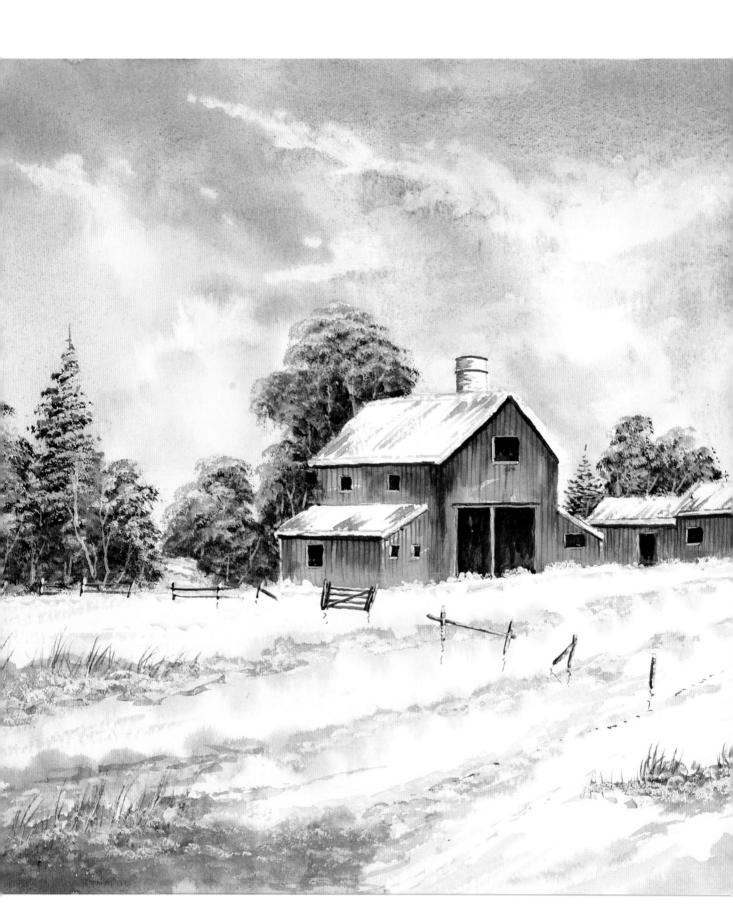

Project 1: Snow and Barns

ACRYLIC WATERCOLOUR

A snow scene makes a good starter painting, bringing together a simple composition with a colourful sky. Despite the blanket of snow, this scene doesn't have to feel cold, and you will see how to combine warm and cool colours to express a bright winter's day.

This project demonstrates how to mix a range of snow colours – blues, purples and greys – which will give your snow scene a natural feel. In addition to the subtle colours in the snow, I will show you how to mix the warmer colours of the trees and bushes.

In order to render the subtle colours in the sky, I will guide you through the wet-in-wet watercolour technique that will be called upon when you paint acrylic watercolours.

The delicate nature of the subject matter calls for careful brush control and you will gain plenty of experience through rendering the soft snow and the detailed buildings, following the guidelines in the Saturday Exercises. By taking the Sunday Painting one step at a time you will soon be on your way to painting with acrylics.

You will need

Paper:	Saunders Waterford (Rough) 640gsm (300lb), 380 x 280mm (15 x 11in)
Brushes:	Old Size 6 rigger for applying masking fluid 20mm (¾in) mop brush Size 6 rigger (sable/synthetic mix) Size 3 rigger (synthetic) 'Unique' Derwentwater and Ullswater brushes (round and angled hog hair)
Additional materials:	Dark brown water-soluble crayon or pencil 20mm (¾in) wide masking tape Masking fluid Hard eraser Absorbent tissue Wonder knife or palette knife
Paints:	Liquitex Heavy Body

Payne's gray · cobalt blue · alizarin crimson · raw sienna · burnt sienna

burnt umber · yellow light hansa · yellow orange azo · titanium white · Hooker's green deep

Saturday Exercises

PAINTING A WET-IN-WET SKY WITH CUMULUS CLOUDS

Painting a watercolour sky isn't difficult, providing you follow the basic rules. To avoid hard edges, or 'cauliflowers' – where the paint dries in unexpected patterns – the sky needs to be painted wet-in-wet in less than four minutes. Here, I used my Sky and Texture brush (see page 15), which is a specially designed hake brush, softer and thicker than a conventional hake.

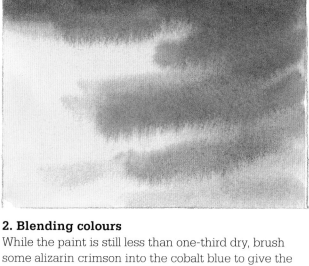

1. Sky under-painting
First, mix a wash of pale raw sienna (a little raw sienna mixed with lots of water) and apply this over the whole paper with a hake brush, using horizontal strokes and working downwards from top to bottom. Before the wash is one-third dry (when the shine is going off the paper), brush in a less wet cobalt blue to represent cloud formations. The clouds will fuse into the still wet raw sienna under-painting without hard edges forming.

2. Blending colours
While the paint is still less than one-third dry, brush some alizarin crimson into the cobalt blue to give the clouds a more three-dimensional shape. Keep the colours a medium tone (not too dark) and allow the colours to fuse together.

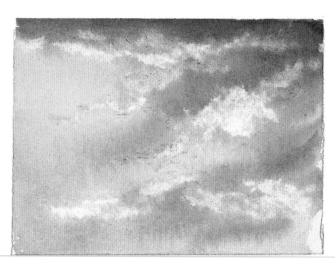

> ### Useful Tip
> Until you have experience of controlling the flow of wet paint, angle your paper very slightly by placing a book under your board.

3. Lifting out cumulus clouds
Before the paint dries, dab and turn a piece of absorbent tissue to remove areas of paint to represent the soft, white cumulus clouds. Keep turning the tissue to find a clean piece and soften any cloud edges. You must continually shape new pieces of tissue, free from paint, otherwise when dabbing you will transfer unwanted paint to other areas.

PAINTING BUILDINGS – AN OLD BARN

When painting buildings, draw in their shapes, taking care to ensure their perspective is correct. If specific areas of the white paper need to be preserved, use masking fluid applied with an old brush. Allow the masking fluid to dry and then overpaint. The sky is always painted first in a painting, so the choice is to mask the whole of the building or to paint masking around the profile of the building to prevent the sky colours running down over the building. When the paint is dry, remove the masking.

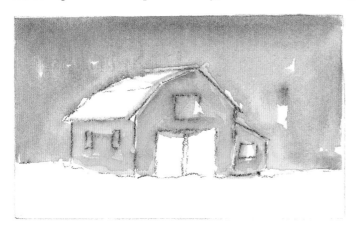

1. Preserving the white paper

Prior to painting the sky, draw the barn with a water-soluble crayon. The roof is covered with snow, so the white paper needs to be preserved. Apply masking fluid with an old Size 6 brush, covering the roof and the edges to represent the depth of snow. Keep dipping the brush in water before applying the masking to prevent the brush becoming clogged. When the masking fluid is dry, brush in the sky colours using the basic principles explained opposite. Apply a pale raw sienna wash over the building.

2. Building colour

Apply a wash of burnt sienna while the raw sienna is still wet and then add a mix of alizarin crimson and burnt sienna to selected areas, such as the shadows under the eaves, to give depth. Don't cover the whole area – allow the raw sienna under-painting to show through.

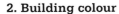

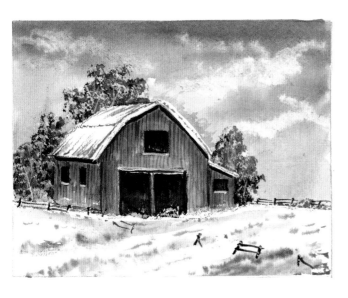

3. Adding details

When the paint is completely dry, paint in the background trees. Allow the paint to dry (use a hairdryer to speed up the drying time), then remove the masking fluid with a hard eraser. Using the rigger brush, paint in the windows and doors using a Payne's gray and alizarin crimson mix. Paint downward strokes with the rigger brush to represent the wood planks, and add some shadows on the roof.

PAINTING SNOW

You need to plan ahead when painting a snow scene, as the most important thing is to leave the white of the paper uncovered to represent the snow. However, snow does not always appear uniformly white. There will be cloud shadows and shadows or reflections from surrounding objects.

1. Foreground snow drifts

Paint the sky and background, leaving the foreground white. Then wet the land area all over with clean water and when slightly less than one-third dry, lightly brush in some cobalt blue to suggest shadows over clumps of grass.

> ### Useful Tip
> The secret when painting watercolours is timing – when to apply the paint. The under-painting should be starting to lose its shine when the next layer of paint is applied. If the under-painting is too wet, the end result will be an undefined blob! If it is too dry, hard edges will result.

2. Wet-in-wet snow colours

While the under-painting is still wet, brush in a cobalt blue and alizarin crimson mix, allowing the colours to fuse together, wet-in-wet. To give a sense of the shadow areas receding into the distance – an effect known as linear perspective – make the angled lines taper from left to right. Using the Wonder knife (my special palette knife, see page 15), scratch in a few lines to represent stubble.

PAINTING LATE SUMMER TREES

There's not much that's more beautiful than trees when their leaves start to turn. Trees are an especially enjoyable subject in acrylics, as you can paint lighter tones over the darker inner foliage. Use dabbing, twitching, stippling and other brush techniques to represent the leaves. I simply stippled the paint to achieve a realistic effect using my two 'Unique' Ullswater tree and foliage brushes (see page 15).

1. Stippling basic shapes

Position a piece of masking tape across the paper to represent ground level, bending the tape to provide a slight curve at the top of the field. Begin by stippling in the rough shapes of the trees using my 'Unique' Derwentwater brush loaded with a mix of Hooker's green deep and burnt sienna. Pat the paper or canvas gently with the tip of the brush to give delicate, light marks; pat harder for larger marks, giving impressions of both small and large leaves. Once the stippling is complete, carefully remove the tape. Scratch in some tree structures using the Wonder knife while the paint is still wet.

2. Building tree foliage

Stipple on the lighter tones of the outer foliage using mixes made from cadmium orange, yellow orange azo, yellow light hansa, alizarin crimson, Hooker's green deep, cadmium yellow deep and titanium white. Don't forget to shape your trees to make them look natural – avoid a series of round blobs and vary the heights.

Sunday Painting

In this first watercolour, the colourful old barns radiate warmth in contrast to the coldness of the snow-covered land and trees. As a first painting, you will bring together a variegated sky using wet-in-wet techniques and contrast the natural forms of the trees against the more solid, structured buildings. I think you will enjoy painting this one.

See page 35 for a list of materials. Begin by drawing the outline using a water-soluble crayon or pencil or alternatively transfer the outline following the instructions on page 11.

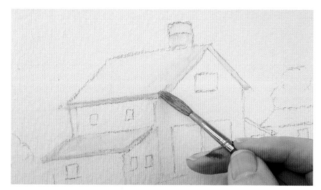

1. Applying masking fluid
Using an old brush, apply masking fluid to the roofs of the barn. Keep rinsing the brush in water before dipping it in the masking fluid to prevent the fluid drying on the brush.

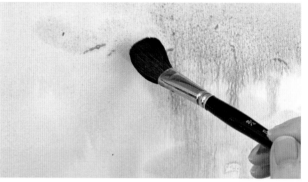

2. Laying in the sky
When the masking is completely dry, paint the sky. Wet the paper all over using the mop brush or hake and brush in some cobalt blue on the right, a weak alizarin crimson into the top left and some raw sienna down to ground level on the left.

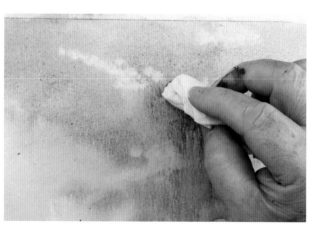

3. Lifting out the clouds
While the paint is still wet, dab the sky area using a tissue to remove paint to represent white cumulus clouds. Do not wipe, simply dab to soak up the colour.

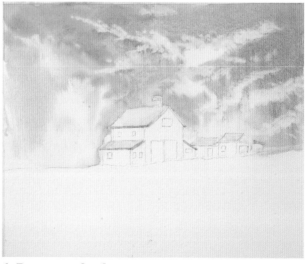

4. Progress check
Keep standing back and looking at your sky to decide where you need to dab to create an interesting sky pattern or cloud shape.

Useful Tip
Use a piece of card as a mask to preserve an area in your painting when applying paint.

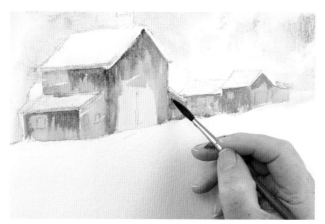

5. Developing the barns
Once the sky area is dry, paint in the barns. Start by applying a weak raw sienna wash over the whole building, using the mop brush. Then over-paint with an alizarin crimson and burnt sienna glaze with the Size 6 brush, using darker tones on selected areas to give the impression of shadows and weathered wood.

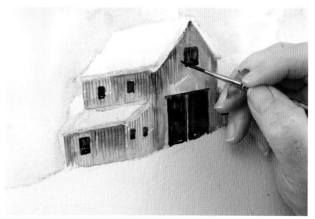

6. Adding detail
When the paint is dry, use the Size 6 rigger loaded with a Payne's gray and alizarin crimson mix to paint the windows and barn doors. Allow this to dry, then use vertical strokes of the same mix to create the effect of slatted woodwork.

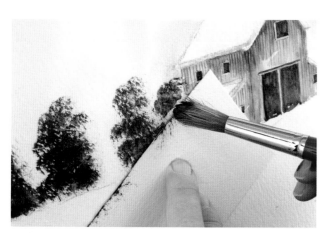

7. Stippling in tree shapes
Start to roughly paint in the tree shapes, using an off-cut of watercolour paper or card as a mask around the profile of the building. Stipple a line of trees with the Derwentwater brush loaded with a Hooker's green and burnt sienna mix.

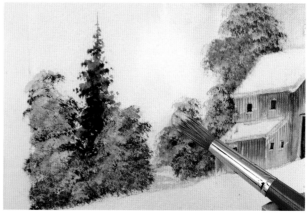

8. Adding outer foliage
Rinse the brush to clean it, then stipple in the lighter tree foliage using mixes of yellow orange azo, yellow light hansa and titanium white. Use the mask to control the paint marks around the buildings. See page 62 for the techniques for painting the fir tree.

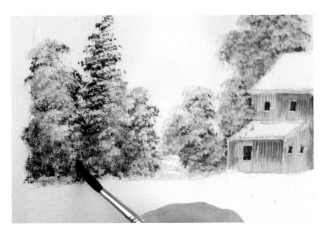

9. Snow-laden branches

Stipple in the white of the snow lying on the tree branches with titanium white, using the Derwentwater brush. Use the angled Ullswater brush for the snow on the fir trees, depositing fine lines of paint to represent the shape of fir tree foliage. Load the Size 6 rigger brush with a shadow colour mixed from Payne's gray and alizarin crimson, and paint in some dark tones to add depth to the trees.

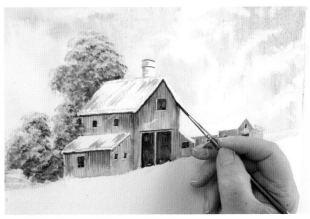

10. Developing the roof

Remove the masking fluid from the roof areas by rubbing with a hard eraser. Using the Size 3 rigger brush loaded with the shadow mix from Step 6, paint in the shadows under the eaves. Then apply a pale mix of cobalt blue and alizarin crimson for the shadows on the roofs, giving the impression of drifts of snow.

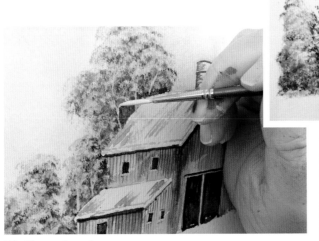

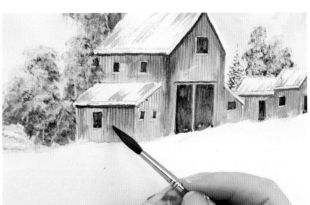

11. Tree structure

With the Size 3 rigger brush and titanium white, paint in some snow- or frost-covered tree structures, adding a little snow on the ledges of the window frames, too.
Inset: To ensure you achieve fine lines, add a little water to the paint to thin it and rest your hand on the paper to control the thickness of the lines.

12. Adding a glaze

To add sparkle to the buildings, wash in a weak alizarin crimson glaze to selected areas on the building with the Size 6 rigger brush. This is easily undertaken with acrylic paints, as unlike traditional watercolour the under-painting will not lift.

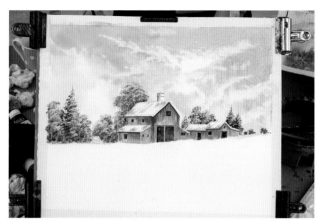

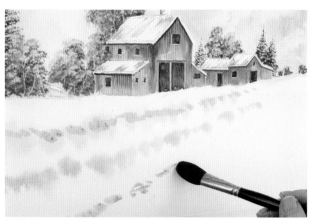

13. Progress check

This shows the painting completed to date. All the trees have now been painted and you will observe that I have varied both the heights and shapes of the trees and bushes. This is vital when painting landscapes to give the viewer variation and avoid boredom.

14. Snow colours

Make a cobalt blue and alizarin crimson mix for the reflected colours of the sky and vegetation on the snow. Wet the foreground area with clean water, load the mop brush with the mix and apply paint by just dancing lightly over the paper. Note how the brushstrokes converge from left to right, giving the impression of recession (linear perspective).

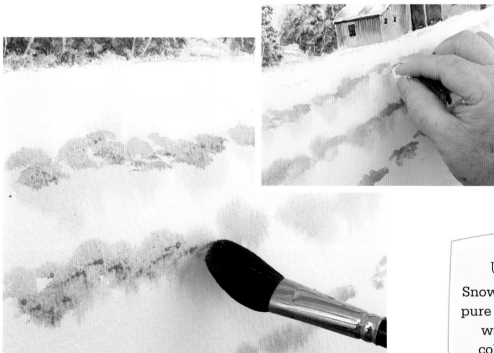

15. Adding depth

While the paint is still wet, drop in a darker value of the previous mix by adding a little more alizarin crimson. **Inset:** Lift off any surplus paint with a crumpled tissue, shaped virtually to a point.

> Useful Tip
>
> Snow is rarely seen as pure white. Its surface will reflect cloud colours and other surrounding objects.

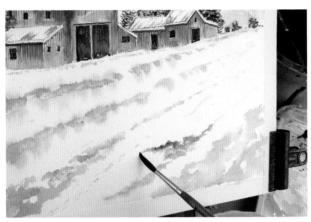

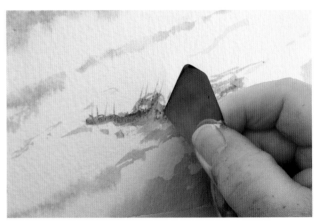

16. Grassy stubble

With the Size 6 rigger brush loaded with a Payne's gray, cobalt blue and alizarin crimson mix, create an impression of patches of stubble by wiggling the brush across the paper.

17. Scratching in texture

Wait until the paint is approximately one-third dry (when the shine is starting to go off the paper), then scratch in some impressions of grass using the Wonder knife. Alternatively, you could use the blade of a cutting knife or a single-edge razor blade.

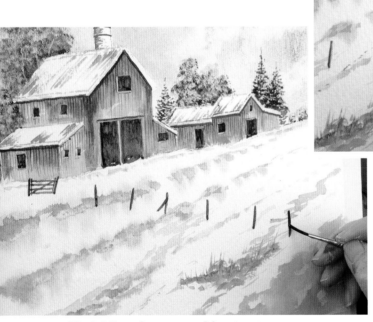

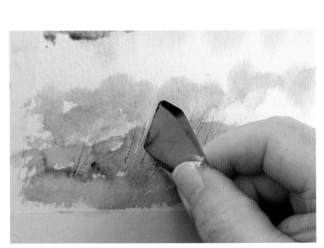

18. Adding foreground interest

Using the Size 6 rigger brush loaded with a Payne's gray and burnt umber mix, paint in the fence posts. This is an old rickety fence with most of the cross bars missing. It has been included to break down the extensive foreground and to add interest to the painting. **Inset:** Continue to work on the fence posts, adding an impression of snow by using the Size 6 rigger loaded with titanium white.

19. Rough stubble

Continue to work across the painting, adding detail. Brush in an impression of stubble at the bottom left, then use the corner of the Wonder knife to scratch in some grasses, as in Steps 16 and 17.

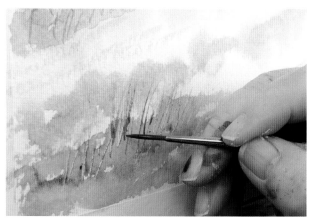

20. Grass
Using the Size 6 rigger brush loaded with burnt umber, paint in a few grass stalks too – just flick the brush upwards from ground level, curving them slightly.

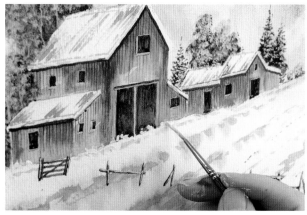

21. Softening lines
With the rigger brush, stipple in some titanium white at the base of the buildings, representing mounds of drifted snow.

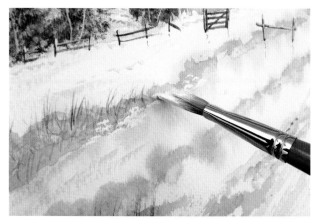

22. Foreground detail
Use the angled Ullswater brush loaded with titanium white to stipple in the effect of snow between the stubble, to soften the artwork and give a more realistic effect.

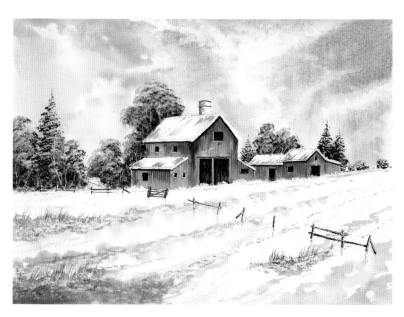

23. The finished painting
Congratulations! You have just completed your first painting.
At this moment you will either be happy with the result or frustrated that it hasn't worked out as well as you had anticipated. Don't worry, you can always over-paint to correct mistakes – that's the beauty of acrylics – or you can treat this as an exercise and paint it again until you get it right. All artists have moments of elation when things go well and moments of despair when they don't. You can do it if you really want to!

Project 2: Sea and Beach

ACRYLIC ON CANVAS

This is a simple project to introduce you to the techniques of applying paint to canvas. Beach scenes are ideal for discovering the wide range of brushstrokes that you can use on canvas – with different strokes, and differing thicknesses of paint, you can achieve thin clouds, textured rocks and breaking waves.

The Saturday Exercises introduce the basic elements required for any beach scene: how to lay an under-painting and blend colours on canvas for the sky; using your brush to represent waves; adding texture to the beach and creating rock formations; discovering how to exploit tonal values to your advantage.

As an exercise in simple composition, this painting demonstrates how to position your horizon and how to balance the different elements, and as you work through the Sunday Painting you will see how the different elements work together.

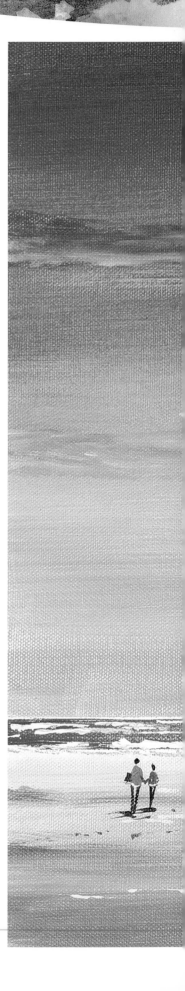

You will need

Canvas:	Winsor & Newton canvas board or stretched canvas, 406 x 406mm (16 x 16in)
Brushes:	Whopper brush (40mm (1½in) flat hog hair brush or quality house painting brush) x 2 25mm (1in) flat brush (bristle) 20mm (¾in) flat brush (sable/synthetic mix) Stippler (25mm (1in) quality house painting brush) Size 3 rigger (synthetic) Size 6 rigger (sable/synthetic mix)
Additional materials:	Dark brown water-soluble crayon or pencil 20mm (¾in) wide masking tape
Paints:	Liquitex Heavy Body

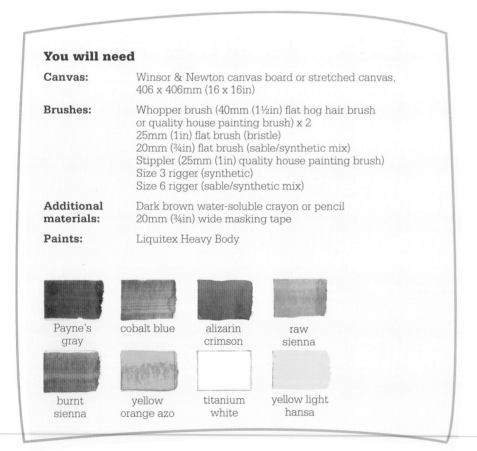

Payne's gray cobalt blue alizarin crimson raw sienna

burnt sienna yellow orange azo titanium white yellow light hansa

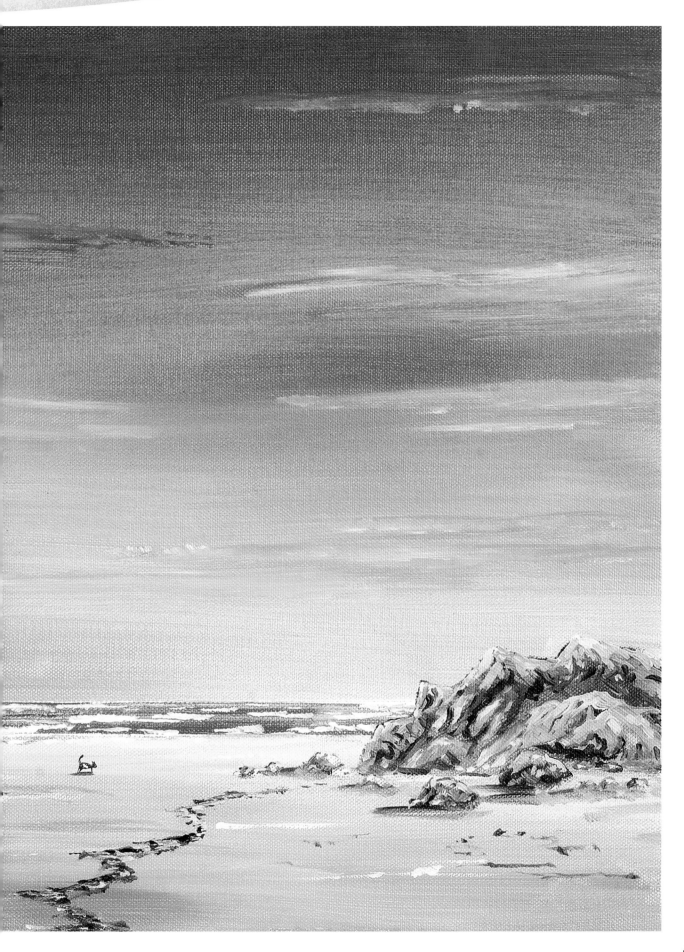

Saturday Exercises

APPLYING PAINT

Before you start painting on canvas you need to know how to apply the paint. The hairs on your brush need to be moist, not too wet. Dip your brush in water and remove surplus water on kitchen paper before moving paint. To apply the paint, use criss-cross strokes (A), followed by horizontal strokes (B) to cover the canvas.

A

B

> ### Useful Tip
> Make sure your under-painting is not too wet, otherwise the paint you apply on top will skid across the canvas, rather than being deposited.

PAINTING AN EVENING SKY WITH STRATUS CLOUDS

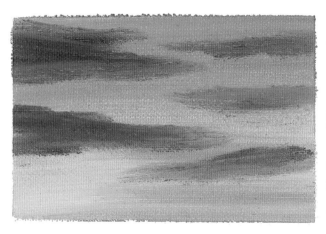

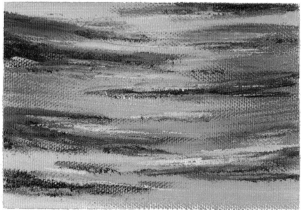

1. Laying an under-painting
Apply an under-painting of raw sienna mixed with titanium white, covering the canvas with even colour and keeping the paint moist but not wet. The next stage is to brush in some thin stratus clouds with an alizarin crimson and cobalt blue mix and two of my Whopper brushes: using horizontal strokes, use one brush to apply paint and another to gently brush across the deposited paint to blend the colours together.

2. Adding depth to the clouds
Brush in a darker value of the cloud mix (with more cobalt blue added) and, using the edge of the brush, add titanium white to selected areas. Move the dry brush lightly across the surface to smooth out the deposited colour. Easy.

PAINTING SEA AND FIGURES

To paint an impression of distant sea, position two pieces of masking tape across the canvas – the bottom of the first tape to represent the horizon, and the top of the second to represent where the sea reaches the shore.

1. Band of water
Use the 20mm (¾in) flat brush loaded with cobalt blue to paint an impression of water. Brush in the paint using the edge of the brush to represent wave levels. When you remove the masking tape, the level edges will give the impression of a band of water.

2. Adding white water
The next stage is to stipple in some white to represent the crests of waves, using the chisel edge of the flat brush loaded with titanium white paint. Keep the linear feel, with thinner lines in the distance and looser lines where the waves break on to the shoreline.

Wave forms
With the 20mm (¾in) flat brush, paint in the wave forms with curved brushstrokes. For an impression of deeper waves, over-paint the cobalt blue with a little Hooker's green deep.

Beach life
A few figures in a beach scene can make a real difference. Using bright colours, such as red, orange or a contrasting green, will draw the viewer's eye and create points of interest. (See page 26 for how to paint impressions of figures.)

PAINTING A SANDY BEACH

When you view a beach scene with squinted eyes, you will see not just an overall sand colour but a variety of shadow colours from the sky, lights and darks where water glistens on the sand and any rocks, pebbles or seaweed left by the tide. In addition, there may be well-established channels and ridges in the sand, created as the tide turns.

2. Adding variety
Brush in burnt sienna to the middle distance, and burnt sienna and cobalt blue mix to the foreground – but don't cover all the raw sienna under-painting. Use two brushes to blend the colours together, as described on page 48.

1. Uniform under-painting
With the sky and background already established, commence by brushing in a raw sienna and titanium white mix for the under-painting (see page 48).

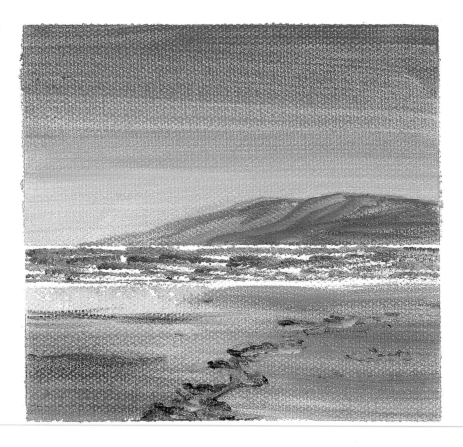

3. Building details
Finally, use the Size 6 rigger brush to paint in a few horizontal lines to represent shadow colours, water pools or varying levels in the beach. Here, I have added interest by painting a water channel or gully by wiggling my rigger brush loaded with a cobalt blue and burnt sienna mix.

PAINTING ROCKS

Rocks and cliffs come in many forms, but the techniques for painting them are roughly the same, although their colours and structure obviously vary from place to place. Their structure must be represented realistically to fit into the landscape. Below I have shown three different examples for you to practise.

Close-up rocks
Apply the under-painting with a 20mm (¾in) flat brush loaded with a Payne's gray and burnt sienna mix. Over-paint with lighter values of raw sienna to represent the shape of the rock formation, leaving some of the under-painting showing through to represent shadows. Turn the brush to follow the shape of the rock.

Distant cliffs
In this example, the rocky cliffs recede into the distance and this is indicated by painting the distant cliffs in lighter tonal values (an effect known as aerial or atmospheric perspective), using variations of the raw sienna, burnt sienna and Payne's gray mix used above. Use dabs of pure white where the sea crashes against the rocks.

White water on rocks
This is a useful exercise. Note the varying heights and profiles of the rocks. The waves splashing against the rocks are simply painted by dipping your finger in titanium white paint and flicking upwards from sea level.

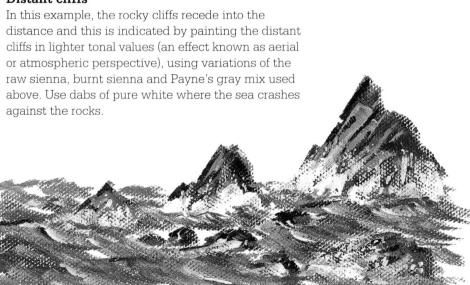

Sunday Painting

This is a very straightforward painting on canvas to get you started, yet it makes a pleasing composition. Here you can experience the calming effect of laying graduated colours for a summer sky, with an introduction to blending techniques to achieve smooth transitions of colour. The textured rocks and incidental figures call for different brush control – all of which will help to build your confidence in working on canvas.

See page 46 for a list of materials. Begin by drawing the outline using a water-soluble crayon or pencil or alternatively transfer the outline following the instructions on page 11.

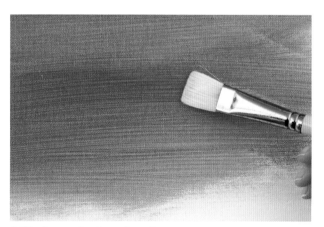

1. Under-painting the sky

Position a piece of masking tape perfectly horizontally across the canvas, so that the top of the tape represents the horizon. Using the Whopper brush or 40mm (1½in) house painting brush, partially cover the sky area (about two-thirds of the way down) with a cobalt blue and titanium white mix (see page 48). The brush should be moist, not too wet, or when you over-paint the next coat will simply skid over the under-painting.

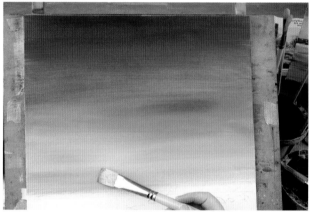

2. Adding bands of colour

At the top of the sky, brush in some alizarin crimson, then paint a raw sienna and titanium white mix on the bottom third of the sky down to the masking tape. Don't worry if you brush over the top of the tape.

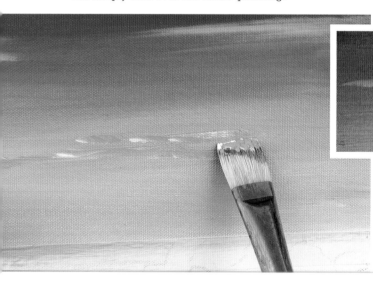

3. Adding stratus clouds

With the 25mm (1in) flat, brush in the clouds using a yellow orange azo, yellow light hansa and titanium white mix. Use the very edge of the brush to suggest the linear nature of the clouds. **Inset:** Brush in a little alizarin crimson and titanium white mix to the top of the sky.

4. Blending colours

Before the paint is dry, gently brush over these cloud deposits with the Whopper brush to blend them into the background, removing any unwanted peaks of paint and smoothing the surface. Remove the masking tape.

> **Useful Tip**
> Use masking tape to control the distribution of paint and to create a horizontal line that represents the horizon or seashore.

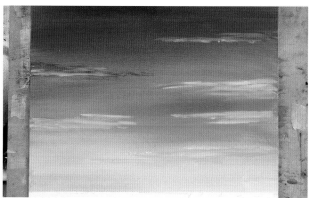

5. Progress check

The sky is now complete. Note how the thin, high stratus clouds blend into the overall sky area with a smooth transition that realistically represents their nature. The warmer, richer colours at the top of the painting convey the intensity of a summer sky.

6. Band of sea

Position a piece of masking tape across the canvas to represent the seashore and paint in an impression of sea using the 20mm (¾in) flat loaded with cobalt blue. Add some streaks of titanium white to represent waves. Remove the masking tape.

7. Building the waves

Complete the impression of waves by depositing titanium white using a dabbing action, working from left to right. Dab rather than stroke with the edge of the brush.

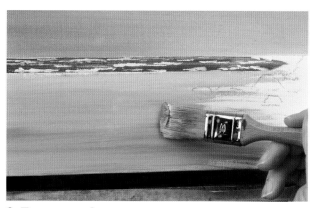

8. Foreground

Drag the Stippler loaded with a raw sienna and titanium white mix across the canvas to paint in the sand. Paint a little burnt sienna here and there to create variation.

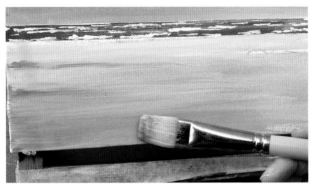

9. Foreground shadows
Using the 25mm (1in) flat brush, paint in a purple colour mixed from cobalt blue and alizarin crimson to the sand. Add a few shadow lines of cobalt blue using the edge of the brush.

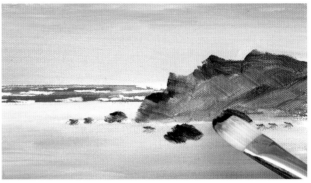

10. Building the rock forms
Now work on adding the rocks on the right-hand side. Rough out their form with a raw sienna under-painting, then over-paint with a burnt sienna and Payne's gray mix to give depth.

11. Adding shape
With the Size 3 rigger brush loaded with a titanium white and raw sienna mix, create the shapes of the rocks, following the lines of the peaks to give them a three-dimensional form.
Inset: Continue shaping the rocks by applying darker values of a Payne's gray and alizarin crimson mix and highlights with a titanium white and raw sienna mix. Paint some shadows under the rocks to link them to the sand, using the burnt sienna and Payne's gray mix.

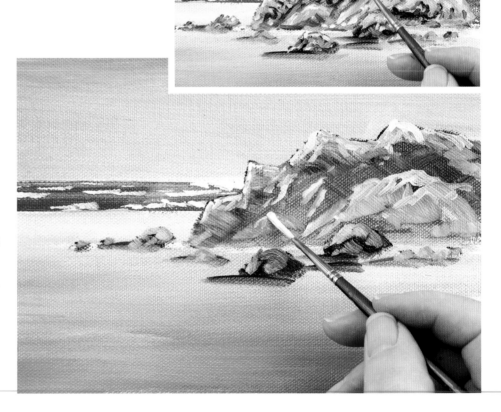

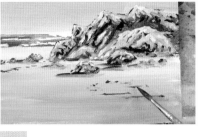

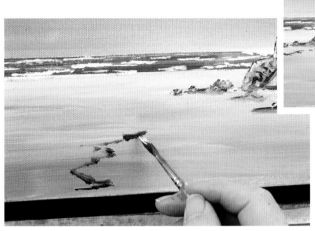

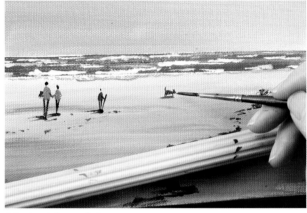

12. Foreground detail

It's time to add interest to the foreground. Using the Size 6 rigger loaded with a Payne's gray and burnt sienna mix, wiggle a line of paint to represent a water channel. **Inset**: Continuing across the foreground, create a few more small rocks and breaks in the sand with the same mix.

13. Incidental figures

Figures walking on the beach can make a significant difference to the composition. Use the techniques shown on page 26 to paint in a few figures – an odd number seems to work best. Use bright colours for contrast, and add shadows. The introduction of a small dog provides the finishing touch.

> ## Useful Tip
> Add interest to your beach by painting some water channels, small rocks or other features.

14. The finished painting

Congratulations – your first painting on canvas! Well, there it is – a simple composition for your first attempt. I never complete a painting in one sitting. I like to look at it over a period of a few days to see if I need to make any changes – here I have added some lighter values in the water channel.

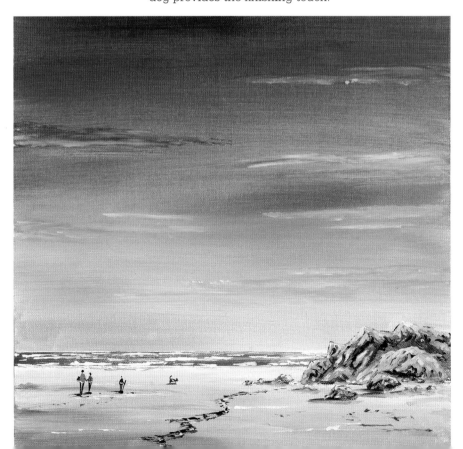

Gallery Exercise – 'Grazing'

ACRYLIC WATERCOLOUR

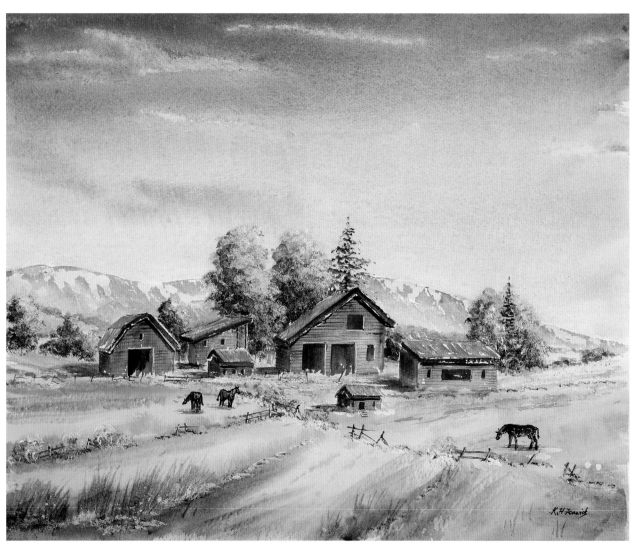

Paints:

Payne's gray cobalt blue alizarin crimson raw sienna Hooker's green deep yellow light hansa burnt sienna

Considerations:

- To create distance, paint the mountains in lighter values.
- The colourful barns are a feature; vary their heights and shapes.
- Note the light and dark values in the grass and that the brushstrokes converge from left to right (creating perspective).
- The horses add life to the landscape (see page 27).

How it was painted:

- Sky – Wet-in-wet, cobalt blue wash with a few clouds drawn out with an absorbent tissue.
- Buildings – Woodwork in raw sienna and burnt sienna mixes, roofs in alizarin crimson and burnt sienna mix.
- Trees – Painted by stippling with the 'Unique' brushes (see page 62).
- Grass paddock – Painted with the 40mm (1½in) hake brush

Techniques:

- Wet-in-wet Sky with Cumulus Clouds, page 36.
- Buildings, page 37.
- Background trees, page 82.
- Fir Trees, page 62.

Paper:

Saunders Waterford (Rough) 640gsm (300lb), 380 x 280mm (15 x 11in)

Gallery Exercise – 'Evening'

ACRYLIC ON CANVAS

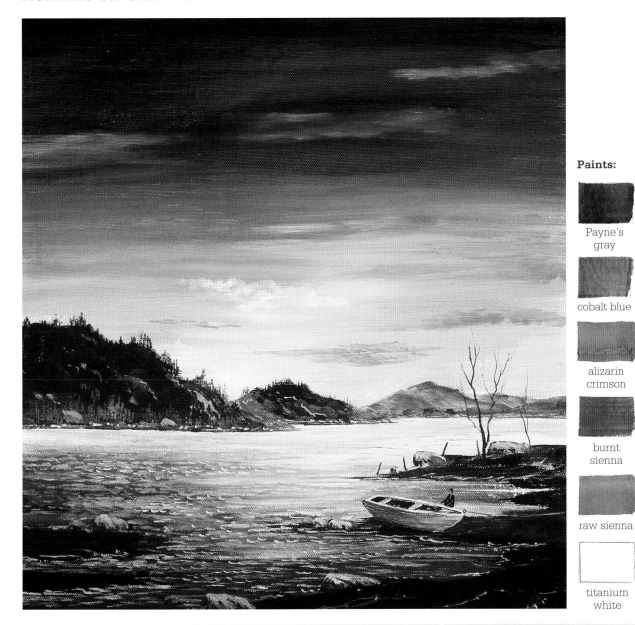

Paints:

Payne's gray

cobalt blue

alizarin crimson

burnt sienna

raw sienna

titanium white

Considerations:

- Introduce a variety of lights and darks in the sky.
- Paint the land from dark on the left to light on the right.
- Reflect the colours of the sky in the water.
- Add the boat and boatman to balance the painting (see page 63).

How it was painted:

- Sky – Painted with the Whopper brush using Payne's gray, cobalt blue and alizarin crimson mixes over a raw sienna and titanium white under-painting.
- Land – A few lighter rocks were painted here and there to add interest to the darker valued hills.
- Water – This is a feature in this painting. The sky colours have been reflected on to the surface of the lake. The chisel edge of the 20mm (¾in) flat brush loaded with a raw sienna and titanium white mix was used to paint in the ripples on the surface.

Techniques:

- Evening Sky with Stratus Clouds, page 48.

Canvas:

Winsor & Newton canvas board, 406 x 406mm (16 x 16in)

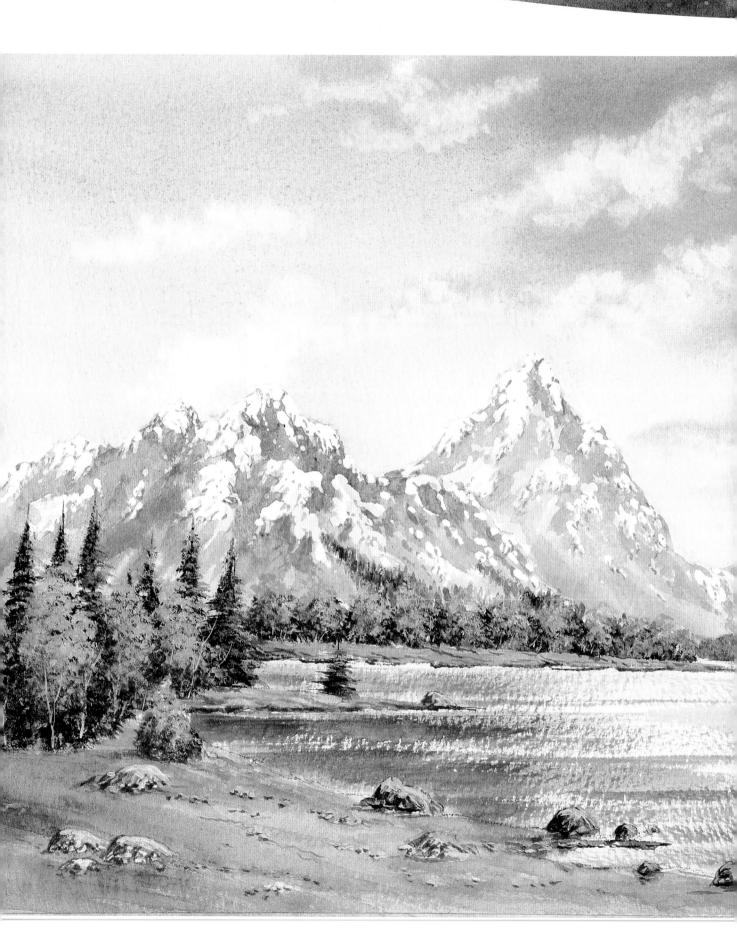

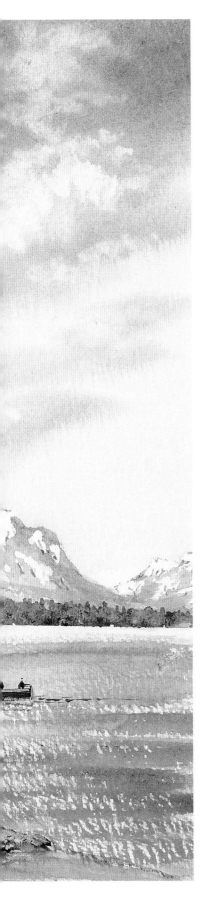

Project 3:
Mountains and Lake

ACRYLIC WATERCOLOUR

The different elements of this painting give me the opportunity to demonstrate several watercolour techniques. Start by practising the Saturday Exercise for a summer sky by blotting out billowing clouds from a sky wash. Creating snowy peaks is made simple with the use of masking fluid to preserve the white paper.

The trees along the shoreline are another challenge, but their forms are simply rendered through stippled marks, working from dark to light. The Saturday Exercise will guide you through creating a tree grouping that will prove invaluable in your landscape paintings.

In addition to the feature of the rocky mountains, this painting includes an expanse of glittering water, and I will demonstrate how to create sparkle and depth with a light touch of the brush and show you simple ways to render boats.

You will need

Paper:	Saunders Waterford (Rough) 640gsm (300lb), 380 x 280mm (15 x 11in)
Brushes:	Old size 6 rigger for applying masking fluid Sky and Texture brush (40mm (1½in) hake) Size 14 round (sable/synthetic mix) Size 3 rigger (synthetic) 20mm (¾in) flat (sable/synthetic mix) 'Unique' Derwentwater and Ullswater brushes (round and angled hog hair) Size 6 rigger (sable/synthetic mix)
Additional materials:	Dark brown water-soluble crayon or pencil Masking fluid Absorbent tissues Hard eraser (for removing masking fluid) 20mm (¾in) wide masking tape Wonder knife or palette knife
Paints:	Liquitex Heavy Body

Payne's gray cobalt blue alizarin crimson raw sienna burnt sienna

yellow light hansa vivid lime green titanium white yellow orange azo Hooker's green deep

Saturday Exercises

PAINTING A CUMULUS SUMMER SKY

The most realistic watercolour sky is one that is painted wet-in-wet. This simply means you wet the paper and then brush in wet paint to represent the clouds. The secret of watercolour painting is knowing how wet the paint is on the brush in relation to the wetness or dryness of the under-painting. Timing is very important to avoid hard edges forming.

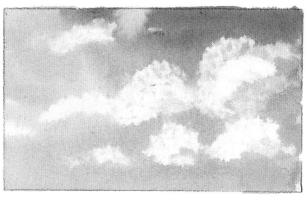

1. Wet sky washes
First wet the paper with clean water and, before the shine has left the paper, brush some pale raw sienna into the left-hand side and cobalt blue on the right using my Sky and Texture brush. Don't incline your painting surface more than five degrees until you develop more skill and confidence to control the flow of paint.

2. Blotting out clouds
Before the washes dry, blot out the cumulus cloud shapes using a shaped pad of absorbent tissue. Vary the sizes of the clouds, keeping the bases relatively flat in contrast to the fluffy tops.

3. Adding depth
Cumulus clouds appear to have flattish bases and this can be represented with shadows, helping to define their shape. Let the paint dry and then paint the shadows in. With clean water, wet a few clouds at a time and using the Size 6 rigger and a pale mix of cobalt blue and alizarin crimson, dab on some colour and let it blend in. Control the blending with the point of a tissue. Don't forget linear perspective: larger clouds at the top, receding to smaller clouds near the horizon.

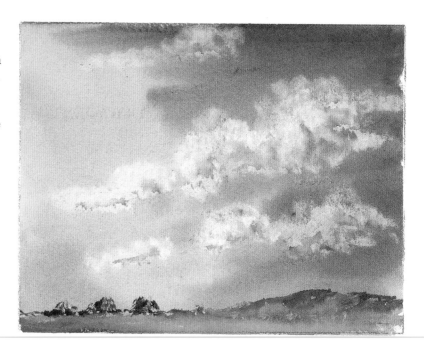

PAINTING SNOW-CAPPED MOUNTAINS

This exercise demonstrates how to give the impression of craggy forms and snow-filled gullies by using masking fluid to 'paint out' the ridges, thus preserving the white paper and representing the deposits of snow.

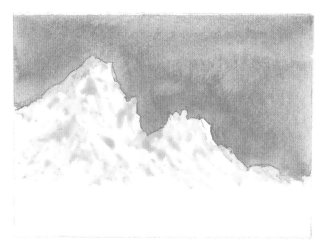

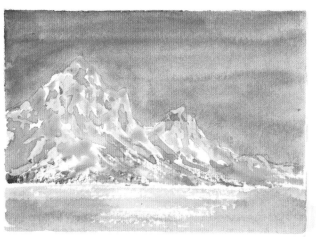

1. Masking ridges and snowy peaks
Draw the shape of the mountain range with a dark brown water-soluble crayon and with an old Size 6 rigger brush apply masking fluid to the ridges and elsewhere to preserve the paper to represent deposits of snow.

2. Applying a wash
Once the masking fluid is perfectly dry, brush over the mask with a pale cobalt blue wash and a cobalt blue and alizarin crimson mix, using the darker mix to represent the shadows between ridges and crags.

> **Useful Tip**
> Use the largest brushes possible in relation to the size of your painting and the minimum number of brushstrokes to ensure freshness.

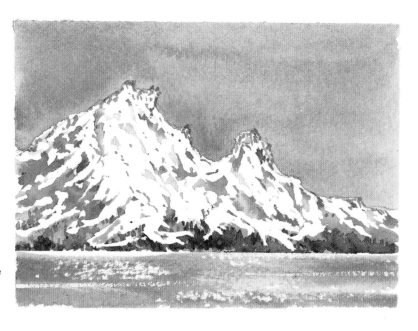

3. Removing the mask
Gradually build up the structure of the mountains with darker tones. When the paint is completely dry, remove the masking with your finger or a hard eraser to reveal the snow-capped mountains. I may use the rigger brush loaded with titanium white paint to refine the deposits of snow, until I am satisfied with the end result.

PAINTING A TREE GROUPING

A group of trees may appear rather complicated, but this exercise shows you how to represent a variety of forms using some simple shapes and techniques that gradually build up to a unified whole. This grouping includes a variety of trees and bushes, some distant ones across the lake and different forms in the foreground.

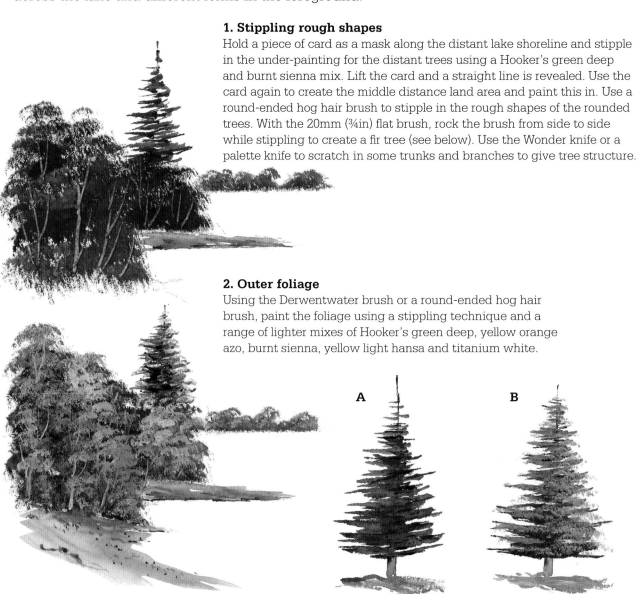

1. Stippling rough shapes

Hold a piece of card as a mask along the distant lake shoreline and stipple in the under-painting for the distant trees using a Hooker's green deep and burnt sienna mix. Lift the card and a straight line is revealed. Use the card again to create the middle distance land area and paint this in. Use a round-ended hog hair brush to stipple in the rough shapes of the rounded trees. With the 20mm (¾in) flat brush, rock the brush from side to side while stippling to create a fir tree (see below). Use the Wonder knife or a palette knife to scratch in some trunks and branches to give tree structure.

2. Outer foliage

Using the Derwentwater brush or a round-ended hog hair brush, paint the foliage using a stippling technique and a range of lighter mixes of Hooker's green deep, yellow orange azo, burnt sienna, yellow light hansa and titanium white.

A B

Fir Trees

Fir trees have a very defined, triangular shape that is best represented with side-to-side strokes of the brush. Apply an under-painting of Hooker's green deep and burnt sienna mix following the general form of the tree. Over-paint light strokes of Hookers' green deep, stippling as you move the brush from side to side, using the edge of the 20mm (¾in) flat brush (A). Once the paint is dry you can stipple lighter highlights on top using the 'Unique' angled Ullswater brush with a pale blue-green mix (B).

PAINTING BOATS

Boats come in many shapes and sizes and make perfect subject matter for a sketchbook. Build up a resource that can be referred to when painting indoors and complement your sketches with lots of photographs.

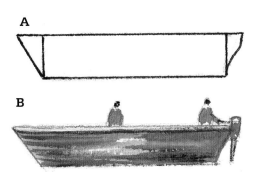

A

B

Distant boats, side view

For distant boats on a lake, it's easy to draw a rectangle with triangles at the front and rear (A). Add strokes of paint following the horizontal form of the boat to give an impression of boarding or wood cladding. Add a couple of indistinct figures with spots of colour to provide focus (B).

Head-on view

A fishing boat coming towards you is represented by drawing the shape of a wine glass for the hull, topped with a cabin and mast.

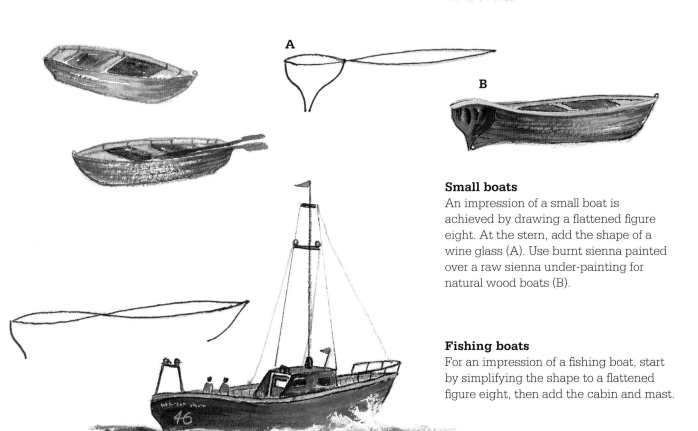

A

B

Small boats

An impression of a small boat is achieved by drawing a flattened figure eight. At the stern, add the shape of a wine glass (A). Use burnt sienna painted over a raw sienna under-painting for natural wood boats (B).

Fishing boats

For an impression of a fishing boat, start by simplifying the shape to a flattened figure eight, then add the cabin and mast.

Sunday Painting

Mountains are naturally dominant landscape features and provide a dramatic backdrop for this project, their jagged shapes contrasting with the soft forms of the cumulus clouds. The project uses watercolour techniques to convey the many different textures of this landscape – from trees and water to rocks and sky.

See page 59 for a list of materials. Begin by drawing the outline using the water-soluble crayon or pencil or alternatively transfer the outline following the instructions on page 11.

1. Masking the peaks

Once you have drawn or transferred the composition, use an old brush to apply masking fluid to the mountain peaks and selected areas where the white paper needs to be preserved to represent snow. Allow the masking fluid to dry.

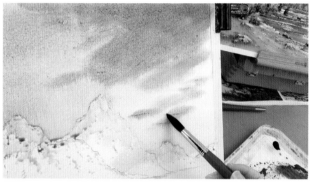

2. Sky wash

With the Sky and Texture brush, wet the paper with clean water and brush in a weak wash of cobalt blue. Follow this by brushing in a weak cobalt blue and alizarin crimson mix to the right-hand side, working around the mountain range.

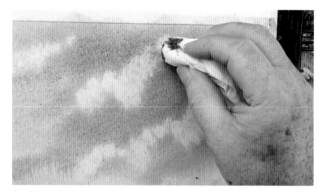

3. Cloud formations

Using an absorbent tissue, dab out colour to create cloud formations. Refer to the finished painting on page 58 for their rough shapes and position, remembering to introduce a sense of recession by making them thinner on the left-hand side.

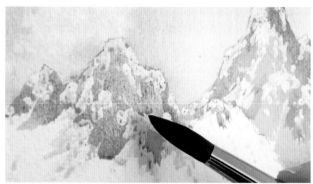

4. Mountain structures

Paint the ridges, peaks, crags and gullies of the mountain structures using the Size 14 round brush loaded with varying mixes of cobalt blue and alizarin crimson. Paint over the dry masking fluid.

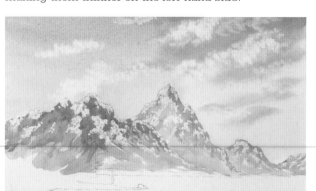

5. Progress check

At this stage the sky and mountain range are established. When the paint is perfectly dry (use a hairdryer if necessary), remove the masking fluid with your finger or by rubbing with a hard eraser.

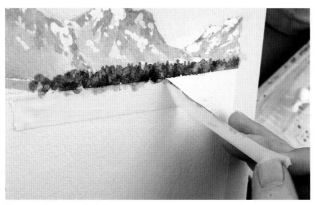

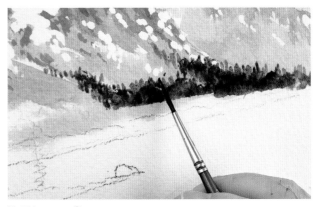

6. Masking off the water line

Position a piece of masking tape, with the top of the tape representing the base of the mountains (water level) and paint in the far right tree grouping, using a Hooker's green deep and yellow light hansa mix When dry, remove the masking tape.

7. Distant fir trees

Using the Size 3 rigger brush loaded with the mix from Step 6, paint in the distant fir trees growing up the mountain side. If you pat with the side of the rigger brush, its shape gives an impression of the fir trees.

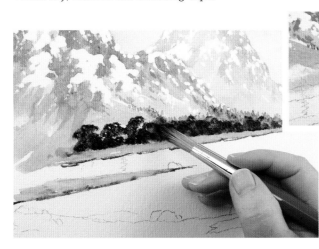

8. Developing the middle distance

Paint the far and middle distant land areas with the 20mm (¾in) flat brush, using mixes made from vivid lime green, yellow light hansa and burnt sienna. Use the edge of the brush to control the paint, reinforcing the edges with a darker burnt sienna wash that defines the shoreline. **Inset:** With the Derwentwater brush, stipple in the underpainting for the distant trees, using Hooker's green deep.

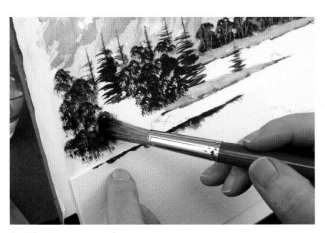

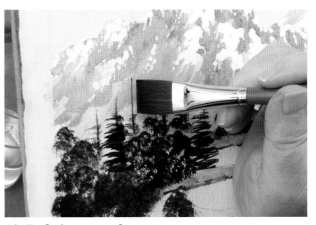

9. Fir tree grouping

Using the techniques shown on page 62, paint the fir trees. Stipple in the middle distant trees using the Derwentwater brush loaded with a Payne's gray and Hooker's green deep mix.

10. Refining tree shapes

Continue to refine the shape of the trees. Use the edge of the flat brush to paint thin lines representing the tops of the fir trees.

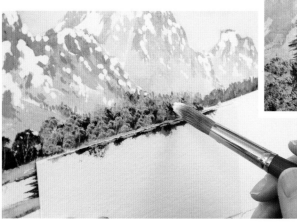

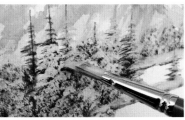

11. Adding foliage

Using the Derwentwater brush, stipple in a mix of yellow orange azo and vivid lime green to create the foliage on the distant trees. **Inset:** Use the angled Ullswater brush to paint the lighter green shoots on the fir trees.

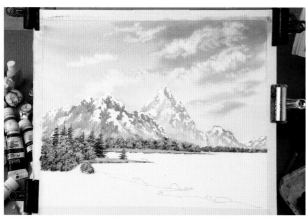

12. Progress check

At this stage of the painting the sky, background mountains and middle distance trees are established. Keep checking your progress before you move on to the next stage.

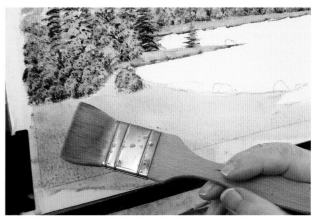

13. Foreground wash

Now start to work on the foreground. Paint the shoreline with the Sky and Texture brush, using raw sienna followed by over-painting selected areas with a wash of burnt sienna.

14. Shaping rocks

When the shine is going off the paper (indicating that it is approximately one-third dry), use the Wonder knife or a palette knife to move paint to shape rocks in the foreground.

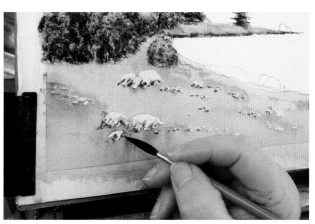

15. Adding definition

When the paint is dry, use the Size 6 rigger loaded with a Payne's gray and burnt sienna mix to paint in the shadow areas on the rocks and at their bases. This links them to the ground.

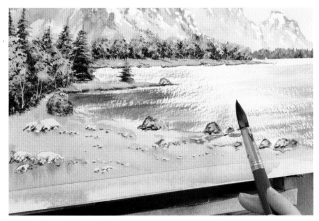

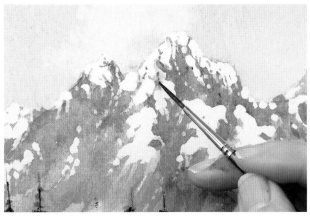

16. Water sparkle

With the warm shoreline established it is time to add the cooler area of water. With the side of the round brush loaded with a cobalt blue and alizarin crimson mix, paint in the water. A light touch of the brush is vital to create the effect of sparkle on the water.

17. Snow shadows

With the painting nearing completion, it is a good opportunity to assess all areas, adding details and refining shadows. Using the No.3 rigger, refine the snow areas by painting in a few shadows along the peaks and ridges.

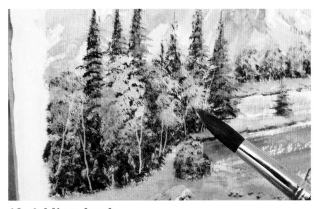

18. Boat detail

Add in a small boat with passengers on the right-hand side of the foreground. This adds interest to the painting and helps to lead the viewer's eye across the composition.

19. Adding depth

With a shadow mix of Payne's gray and alizarin crimson, add depth to the tree groupings.

20. The finished painting

At this stage I like to step back and reassess the painting, refining any details and adjusting colours if called for. Here, I felt it was necessary to add a burnt sienna glaze to the foreground to warm it up a little, emphasizing the contrast with the cool water. I also added depth to the distant trees with dabs of a dark Payne's gray and alizarin crimson mix at the base of the tree canopy.

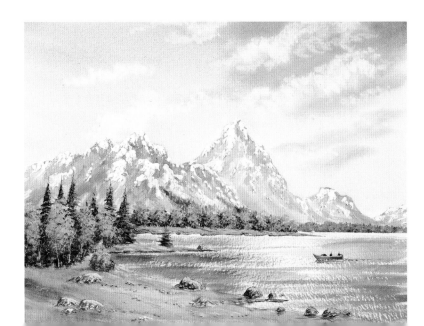

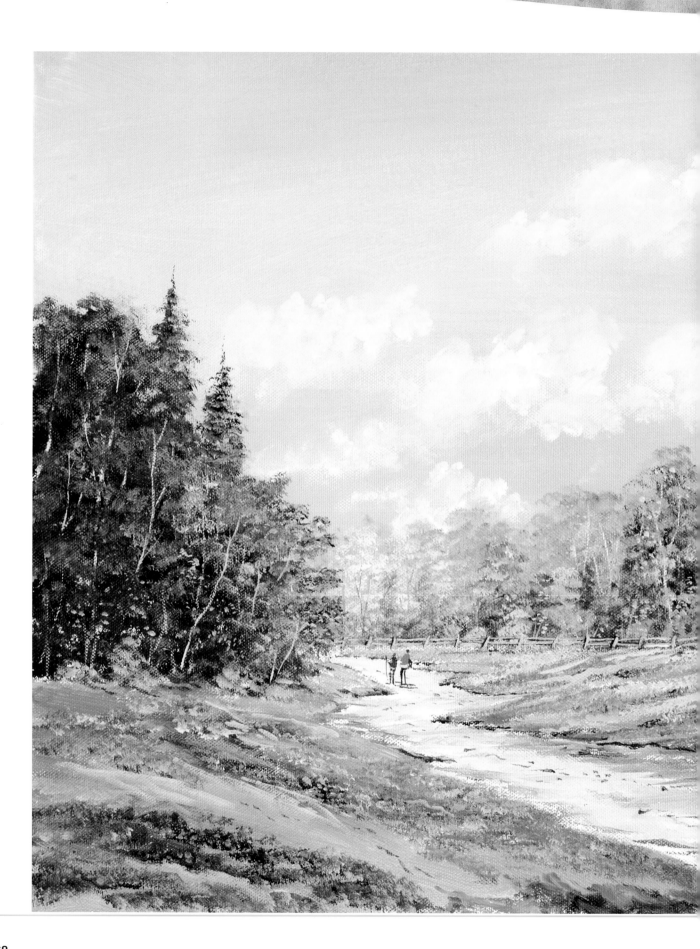

Project 4: Trees and Foreground

ACRYLIC ON CANVAS

This is an exercise in painting tree foliage and how to achieve recession in a painting – the sense of distance. The Saturday Exercises provide a straightforward explanation of the principles of perspective, which you can put into practice in the Sunday Painting, enabling you to apply the basic techniques and achieve a realistic sense of depth in your landscapes.

This scene allows me to demonstrate how to represent the lights and darks found in woodland. Green is a key colour to the landscape painter, and through this exercise you will learn how to mix a wide range of greens.

I will introduce you to a great technique for representing summer clouds on canvas – using your fingers to apply the paint – and give you a range of methods for representing foliage and tree groupings.

Use artistic licence to add figures on the path – this adds interest and a splash of colour to the scene. A few wild flowers dotted here and there also bring life into the painting. I think you will enjoy painting this scene.

You will need

Canvas:	Winsor & Newton canvas board or stretched canvas, 406 x 406mm (16 x 16in)
Brushes:	25mm (1in) flat brush (hog hair) 'Unique' Derwentwater brush (round hog hair brush) Size 6 rigger (sable/synthetic mix) Size 3 rigger (synthetic) Stippler (25mm (1in) quality house painting brush) 20mm (¾in) flat brush (sable/synthetic mix)
Additional materials:	Dark brown water-soluble crayon or pencil Wonder knife or palette knife
Paints:	Liquitex Heavy Body

Payne's gray cobalt blue alizarin crimson raw sienna burnt sienna

cadmium red yellow light hansa yellow orange azo titanium white Hooker's green deep

Saturday Exercises

PAINTING CUMULUS CLOUDS ON CANVAS

I'm going to show you a quick and clever way to paint cumulus clouds on canvas, those big fluffy clouds we see in summertime – like balls of cotton wool in the sky.

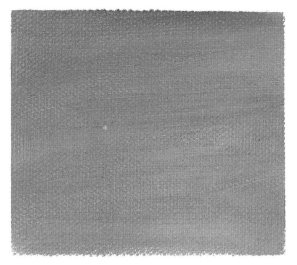

1. Sky background
Commence by painting a cobalt blue background using the criss-cross technique (see page 48) to fill in the canvas. Remember the brush must not be too wet.

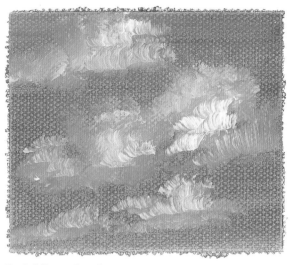

2. Adding clouds
Use titanium white to dab on the paint to represent the rough shape of the clouds. Use the side of a round brush and circular brushstrokes.

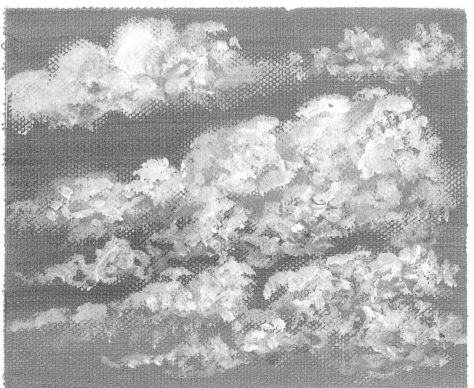

3. Blending
Here's the quick and clever way: use the tip of your finger and circular movements to spread the paint, thinning the colours at the outer edges. Paint in a few shadows using a cobalt blue and alizarin crimson mix and continue blending with your finger.

> **Useful Tip**
> Blending with your finger is very relaxing – and if anyone steals your painting it will have your fingerprints on it!

PAINTING PERSPECTIVE

There are several ways that you can suggest a sense of distance, or recession, in your paintings, and the two principal techniques are aerial and linear perspective. You can combine both in your paintings, and you will notice that they occur in most landscapes.

Aerial perspective

Also known as atmospheric perspective, aerial perspective involves painting distant objects lighter in tone and in less detail, using cooler colours to create the illusion of distance. Foregrounds should be painted in darker values, using warmer colours and in more detail. In this middle distance tree grouping, the nearer trees on the right have been painted in darker values and as they become more distant on the left the colours have been painted in progressively lighter values.

Linear perspective

As a shorthand explanation, linear perspective can be taken to mean that distant objects appear smaller than nearer ones, eventually vanishing as they converge on the horizon. Good examples of this effect are a railway line or straight road where the lines appear to draw closer together with distance, until they meet at the vanishing point, which usually occurs on the horizon. In this sketch, the track appears wider in the foreground and narrower in the distance. Give your paths or farm tracks a meandering shape, rather than a straight line, to make your landscapes more interesting.

PAINTING TREE FOLIAGE

When I first attempted to paint, my greatest difficulty was painting trees that looked like trees rather than lacklustre blobs. After 35 years of landscape painting, I have learnt 15 techniques for painting trees, including dabbing, twitching, pecking, wiggling and stippling with the brush. On these two pages I have used my 'Unique' tree foliage and foreground brushes (see page 15) to complete the exercises.

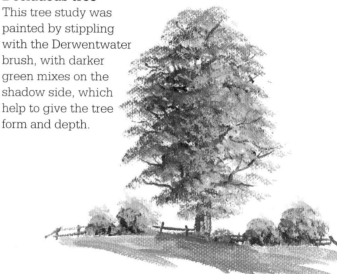

Deciduous tree
This tree study was painted by stippling with the Derwentwater brush, with darker green mixes on the shadow side, which help to give the tree form and depth.

Fall foliage
To paint this colourful group of trees, I stippled with the Derwentwater brush using mixes made from yellow orange azo, cadmium orange and yellow light hansa over an under-painting of Payne's gray and burnt sienna. Leave gaps between the branches to let light through.

1. Tonal values
This tree study was painted by initially stippling the under-painting with a Hooker's green deep and burnt sienna mix. Work the paint into the canvas, using lighter brushstrokes on the outer edges where the foliage is thinner.

2. Outer leaves
The foliage was painted by stippling a wide range of greens mixed from cobalt blue, Hooker's green deep, yellow light hansa and titanium white. The Derwentwater brush was used for the bulk of the foliage and the Ullswater brush for the fir tree.

PAINTING GRASSY FOREGROUNDS

Lush grass and green meadows are as enjoyable to paint as they are to behold. With vibrant mixes of paint and the suggestion of meadow flowers, they will brighten any landscape. Starting with a rich under-painting, you can add flicks of grass or speckled flowers to bring interest and texture to the scene.

Grass

This sketch was painted by stippling with the Ullswater brush. Both light and dark green mixes can be stippled and then blended together by holding the tip of the brush handle and flicking upwards. The angled brush is ideal for this purpose but a fan brush would give a similar effect.

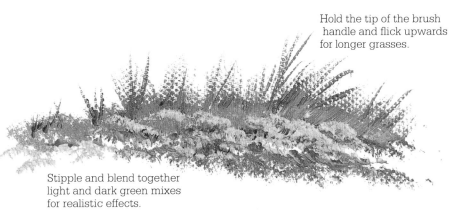

Hold the tip of the brush handle and flick upwards for longer grasses.

Stipple and blend together light and dark green mixes for realistic effects.

1. Grass banks

The foreground grass bank was painted by over-painting a yellow green with a darker value mixed from Hooker's green deep and burnt sienna.

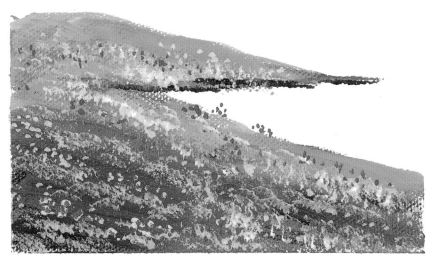

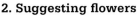

2. Suggesting flowers

When the paint is dry, simply stipple in an impression of flowers with the angled Ullswater brush, using yellow and reds.

Sunday Painting

This woodland scene is primarily an exercise in painting trees and foreground. This painting combines the devices of aerial and linear perspective to give the impression of distance, with the meandering path drawing your eye through to the trees beyond.

See page 69 for a list of materials. Begin by drawing the outline using a water-soluble crayon or pencil or alternatively transfer the outline following the instructions on page 11.

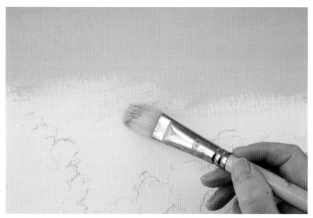

1. Blocking in the sky
Use the 25mm (1in) flat brush and a mix of cobalt blue and titanium white to block in the top half of the sky (see page 48).

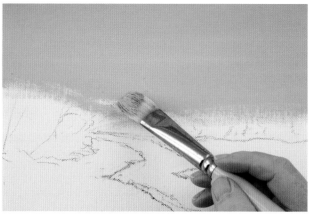

2. Warmer tones
As you work down to the horizon, add a crimson and titanium white mix, blending with the cobalt blue mix, and ensuring that the under-painting is not too wet, to avoid subsequent colours slipping over it.

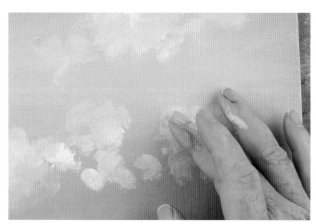

3. Adding clouds
Now paint in the cumulus clouds. Brush in some titanium white and then use your finger to shape the clouds and soften the edges (see page 70).

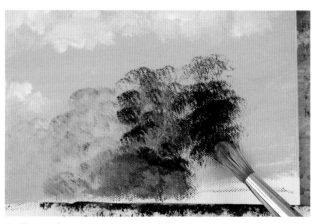

4. Tree shapes
Using the Derwentwater brush, stipple in the rough shapes of the right-hand trees, using a Hooker's green and Payne's gray mix, dabbing the paint and using the shape of the brush mark to describe foliage masses.

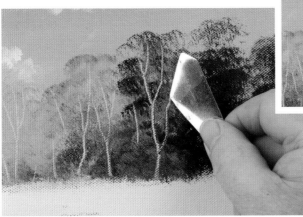

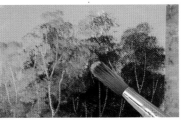

Useful Tip
Use a palette knife to scratch in the tree structures.

5. Tree structure

With the heel of the Wonder knife, scratch in the structure of some trees – trunks and branches – as a guide to where to paint the groups of foliage. **Inset:** With the Derwentwater brush, paint in the foliage using mixes from Hooker's green, yellow light hansa, yellow orange azo and titanium white, with darker foliage on the right, graduating to lighter values on the left.

6. Darker foreground foliage

Roughly paint the left-hand tree grouping using the Derwentwater brush by stippling in mixes of Payne's gray, Hooker's green deep and burnt sienna. When the under-painting is dry, add the lighter foliage using a Hooker's green, yellow orange azo and titanium white mix.

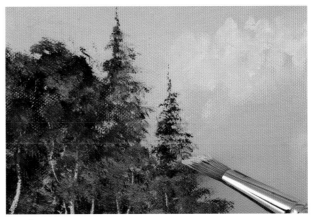

7. Fir trees

To add interest to the composition, paint two fir trees on the edge of the left-hand group of trees (see page 62).

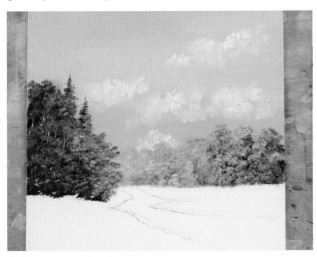

8. Progress check

With the sky and trees established you already have a sense of recession, which is enhanced by the darker values of the left-hand tree group, contrasting with the lighter right-hand trees, leading the viewer's eye along the path into the distance.

9. Adding grassy banks

Brush in the right-hand bank using a cobalt blue and yellow light hansa mix with the Stippler brush. Add some darker tones to create structure on the bank by adding Hooker's green to the above mix. Now build the banks on the left-hand side in a similar way.

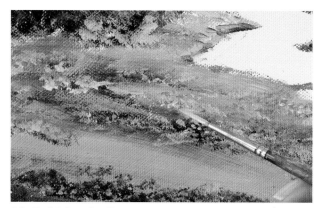

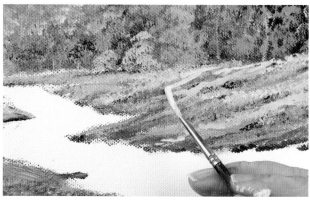

10. Dabbing in flowers

Using the Size 6 rigger brush, paint in a few light green gorse bushes at the base of the dark tree grouping and then load the brush with cadmium red and dab in a few flowers using the point of the brush.

11. Creating highlights

Continue to work in a similar way on the right-hand bank. Refine both banks by wiggling the Size 3 rigger loaded with a yellow light hansa, raw sienna and titanium white mix to create texture and highlights in the grass.

> **Useful Tip**
> Use a rigger brush to dab in a few flower heads.

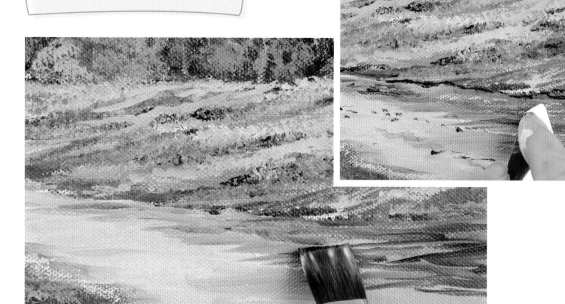

12. Blocking in the path

Load the 20mm (¾in) flat brush with a raw sienna and titanium white mix, and block in the path. Then blend in a cobalt blue and alizarin crimson mix to add depth to the path, suggesting cast shadows and giving variation. **Inset:** Using the point of the Wonder knife, move paint to represent small stones in the path.

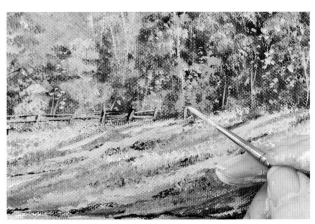

12. Creating depth

Trees are dark on the inside, with lighter foliage displayed on the outside. Wiggle the Size 6 rigger loaded with a Payne's gray and alizarin crimson mix to create shadows, linking the trees to the ground.

13. Adding details

Paint in a few lighter bushes, tree structures and a fence across the right-hand side to build up the details and refine your painting.

14. Adding figures

Finally, paint in two figures walking along the path. The bright red of one figure creates a visual link with the flowers, adding a sense of harmony across the painting and drawing your eye along the path.

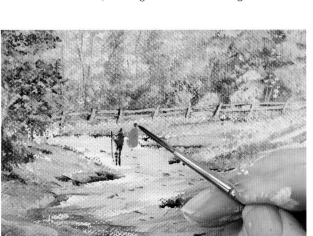

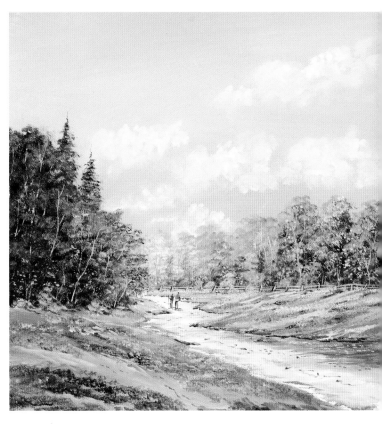

15. The finished painting

Capturing the freshness of a summer's day, this landscape brings together a variety of greens. Note how the viewer's eye is led into the painting, down the path by way of linear perspective and by using aerial perspective in the trees.

Gallery Exercise – 'Bluebell Wood'

ACRYLIC WATERCOLOUR

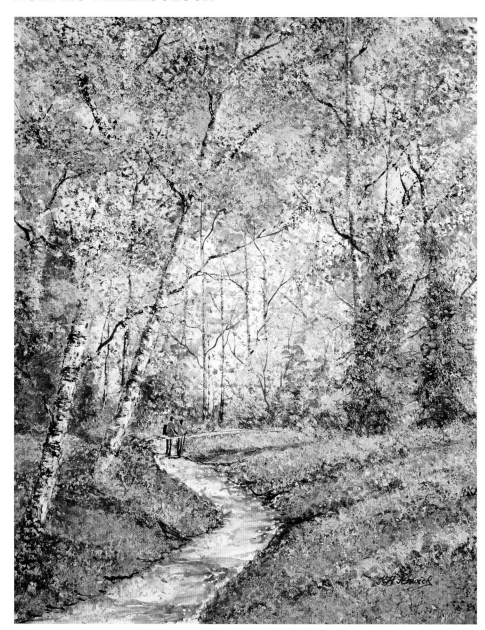

Paints:

Payne's gray

alizarin crimson

cobalt blue

burnt sienna

raw sienna

yellow light hansa

titanium white

Considerations:

- Paint the background sky pale blue.
- Use linear perspective to lead the eye into the painting along the path into the distance.
- Position larger trees in the foreground.

How it was painted:

- Sky – Pale cobalt blue wet-in-wet.
- Trees – Structures masked using masking fluid to allow over-painting.
- Tree foliage – Stippled with a sponge, depositing a yellow green over a dark green background.
- Foreground – Texture created by stippling with a sponge dipped in light and dark green.
- Bluebells – Stippled with a sponge, using a cobalt blue and titanium white mix.
- Tree trunks – Masking removed and effects of tree bark painted using the rigger brush loaded with a cobalt blue and burnt sienna mix. A little alizarin crimson was used for highlights.

Techniques:

- Perspective, page 71.
- Grassy Foregrounds, page 73.

Paper:

Saunders Waterford (Rough) 640gsm (300lb), 380 x 280mm (15 x 10in)

Gallery Exercise – 'On the Lake'

ACRYLIC ON CANVAS

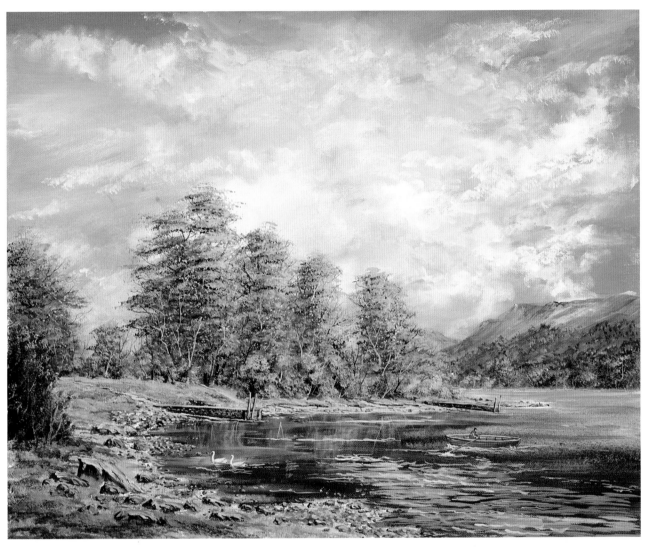

Paints:

| Payne's gray | cobalt blue | alizarin crimson | raw sienna | yellow orange azo | Hooker's green deep | yellow light hansa | burnt sienna | titanium white |

Considerations:

- Paint the dramatic sky with the Whopper brush, softening the clouds with your finger.
- The wide range of fall foliage mixes and their colours is transferred to the land areas.
- Introduce life into the landscape by painting the figures in the boat, together with the swans.

How it was painted:

- Sky – A pale cobalt blue and titanium white under-painting, over-painted with a raw sienna and titanium white mix for the large cloud area. A little alizarin crimson was introduced to selected areas.
- Trees – Painted with the 'Unique' brushes (see page 15) with mixes of raw sienna, burnt sienna, alizarin crimson, yellow orange azo, yellow light hansa, Hooker's green deep, Payne's gray and titanium white.

Techniques:

- Cumulus Clouds on Canvas, page 70.
- Tree Foliage, page 72.
- Land and Rocks, page 94.

Canvas:

Winsor & Newton stretched canvas, 610 x 510mm (24 x 20in)

Project 5: Waterfall

ACRYLIC WATERCOLOUR

This beautiful waterfall in Georgia will provide you with the opportunity to practise a wide range of techniques that you will find beneficial in future paintings. The soft background uses the qualities of wet-in-wet blending to great effect, and the Saturday Exercises show you how to develop your technique further, building on the background to add more detail for the foreground trees, using stippling.

Wet-in-wet is also used for the rock formations, and you will have plenty of opportunity to practise how to build tones and texture before tackling the Sunday Painting.

Painting falling water needs thought and sensitivity and I will show you how to capture the impression of tumbling water without overworking the painting, working either dark over light, or light over dark. In addition to giving some guidance on creating white water at the base of the fall, I will show you how to create sparkle on the water.

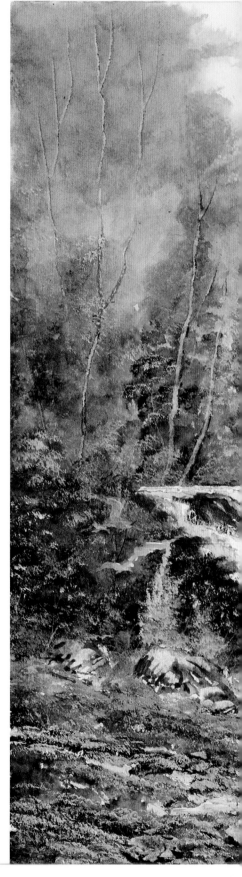

You will need

Paper:	Saunders Waterford (Rough) 640gsm (300lb), 380 x 280mm (15 x 11in)
Brushes:	Sky and Texture brush (40mm (1½in) hake) 'Unique' Derwentwater and Ullswater brushes (round and angled hog hair) 20mm (¾in) flat (sable/synthetic mix) Size 6 rigger (sable/synthetic mix)\ Size 14 round (sable/synthetic mix)
Additional materials:	Dark brown water-soluble crayon or pencil 20mm (¾in) wide masking tape Wonder knife or palette knife
Paints:	Liquitex Heavy Body

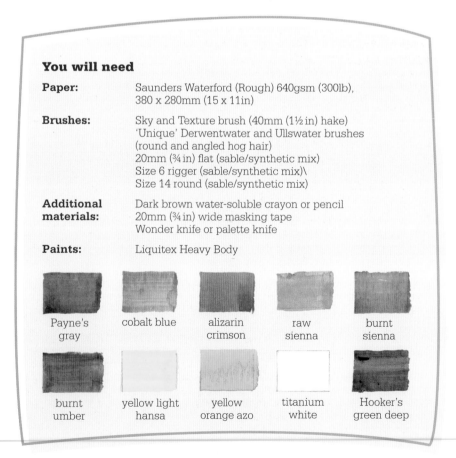

Payne's gray	cobalt blue	alizarin crimson	raw sienna	burnt sienna
burnt umber	yellow light hansa	yellow orange azo	titanium white	Hooker's green deep

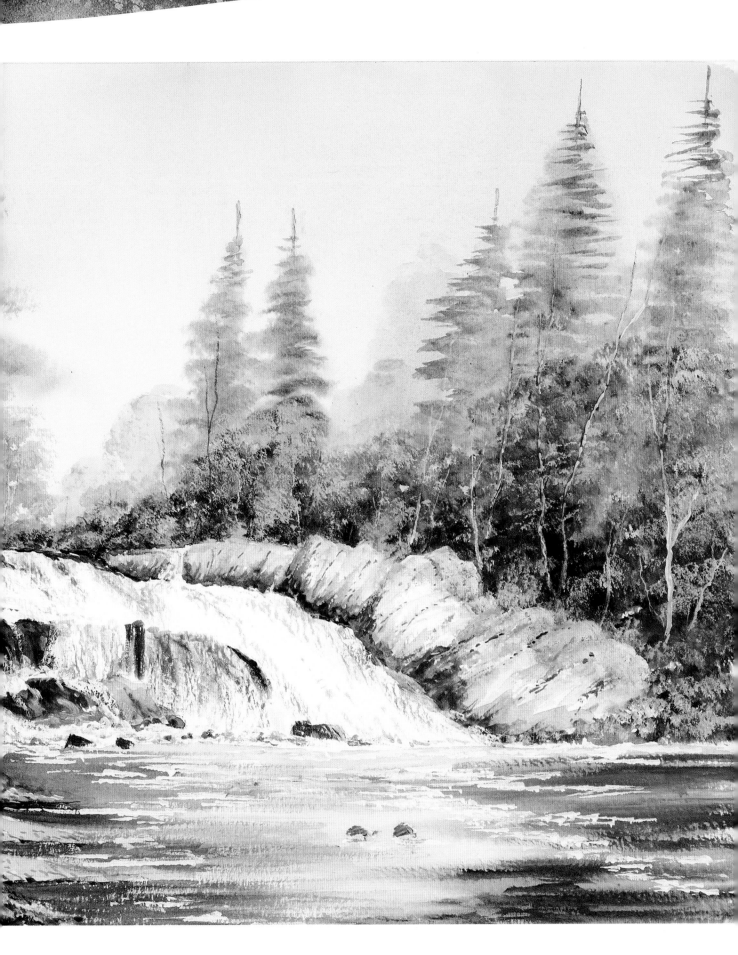

Saturday Exercises

PAINTING BACKGROUND TREES

Distant trees take on a soft, misty outline, and this can be realistically conveyed by painting them wet-in-wet. The colours will blend and merge together. Once dry, more details can be painted to create realistic tree shapes.

1. Wet-in-wet tree shapes

Paint the background trees with a wet wash of Payne's gray and Hooker's green deep, and leave for only a few seconds to partially dry. Using a less wet mix, stipple in the shape of the trees. Timing is important here – the paint should be sufficiently less wet to blend in with the wetter background but still retain some shape. Let the paint dry until the shine has gone off the paper then stipple in the closer trees so that they retain their shape. I have scratched in some tree structures while the paint is still damp.

> ## Useful Tip
> Try using a natural sponge dipped in paint to stipple on the foliage, but don't squeeze the sponge when applying paint.

2. Adding detail

Allow the paint to dry – you can use a hairdryer to speed up the process. Using the 'Unique' brushes, stipple in some brighter colours to create foreground bushes and trees. Add more titanium white to the mixes and stipple on the highlights.

PAINTING WET-IN-WET ROCKS

This exercise demonstrates how to render different types of rock formations using wet-in-wet watercolour techniques, building form and shadows with tones and highlights.

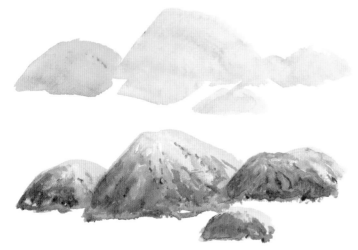

Rounded rocks

This first group of rocks is typical of those to be found in most rivers. Paint the shapes using the 20mm (¾in) flat brush loaded with a pale raw sienna wash. While that is still wet, brush in some burnt sienna, following the form of the rounded sides, and for greater depth use a Payne's gray and alizarin crimson mix. When dry, use the rigger brush to paint a few shadows along some of the weathered ridges and at the base.

Angled rocks

The next group is typical of those projecting from the beach or sea. Use the same brush and colour mixes as above and paint the shapes quickly, following the vertical lines with the darker mixes to emphasize the sharp, flat edges.

Coastal cliffs

When painting coastal cliffs, study the lights and darks, using similar washes to follow the rounded forms and darker mixes for the lower cliffs. Represent fissures or areas in shadow. The distant cliffs should be smaller and paler in tone than those in the foreground, following the principles of aerial and linear perspective (see page 71). Don't be afraid to use colour.

Small rocks

The 20mm (¾in) flat brush is ideal for shaping rocks both large and small. Use the full width of the brush for larger rocks and the corner of the brush for small rocks. Always apply at least three tonal values.

PAINTING FALLING WATER

There are two main techniques for representing falling water – you can paint dark over light or light over dark. Either of these techniques can be employed with acrylics (a big advantage over attempting the same subject matter with watercolour paints) but whichever technique you choose, a light touch of the brush is essential, as is the direction of your brushstrokes, which is dependent on the height of the fall.

Dark over light
Here, I used my Sky and Texture brush loaded with a mixture of cobalt blue and titanium white and gently brushed over the white, rough paper to deposit paint. The paint must not be too wet and you may need to apply several brushstrokes for the desired effect.

Light over dark
Here, the dark background was painted with a mix of Payne's gray and cobalt blue and allowed to dry. The Sky and Texture brush, loaded with titanium white, was lightly brushed over the paper with downward strokes to deposit white paint. The paint must not be too wet or you will not achieve the effect of moving, glistening water.

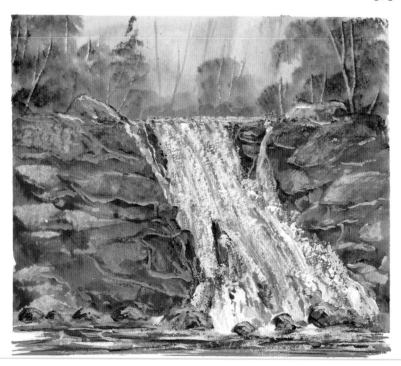

Falling water
Here, I applied white paint over a dark background. To make the fall look natural, I added two rivulets coming over the top of the fall and with the side of the rigger brush loaded with white paint, lightly brushed over the right-hand rocks to create the impression of water splashing over the rocks.

PAINTING FOREGROUND WATER

When painting a lake or river it is important to use several colours to create the feel of a volume of water. Exploit the rough surface of the paper to make the water sparkle. Think of the texture of the paper as being mountains and valleys – the aim is to deposit paint on the top of the 'mountains' and not to allow it to run into the 'valleys'.

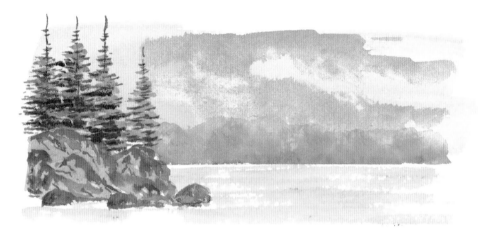

1. Initial light wash
Apply a raw sienna wash to the whole surface of the lake. Allow the paint to dry.

2. Adding sparkle
Now apply a wash of cobalt blue. Using a dryish brush, ensure that the paint adheres only to the 'peaks' of the paper surface – creating sparkle. Use the side (not the point) of a round brush. Allow the paint to dry.

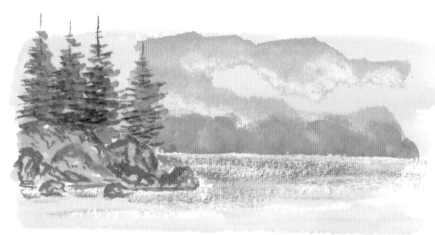

3. Adding shadows
To add realism, apply a cobalt blue and alizarin crimson mix to the left-hand side to represent shadow from the rocky escarpment. Where the wind ruffles the water, add two horizontal lines with the edge of the flat brush and titanium white.

Sunday Painting

The contrast between the soft background trees and the flowing water of the foreground rapids is a key feature of this composition, providing you with lots of opportunities to practise your watercolour techniques: using wet-in-wet blending and lightly brushing over the paper to create sparkle.

See page 80 for a list of materials. Begin by drawing the outline using a water-soluble crayon or pencil, or alternatively transfer the outline following the instructions on page 11.

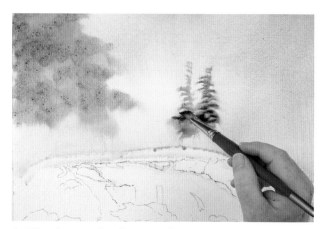

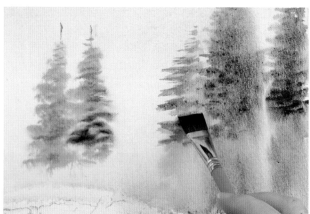

1. Wet-in-wet background
Draw the outline, then position masking tape along the top of the rocks. Using the Sky and Texture brush, wet the sky area with clean water and brush in a watery cobalt blue. When the under-painting is approximately one-third dry (when the shine is going off the paper), brush in the distant tree shapes wet-in-wet, using the Derwentwater brush for the larger masses and the Ullswater brush for the fir trees (see page 62), with mixes of Hooker's green deep.

2. Tree profiles
Continue to rough out the profiles of the right-hand trees using the 20mm (¾ in) flat brush and mixes of Hooker's green deep and yellow light hansa, dabbing and moving the paint with the edge of the brush to follow the form of the branches.

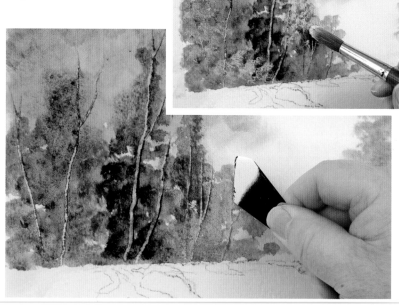

3. Tree structures
Work across the painting and stipple in the left-hand tree structures above the fall using Hooker's green deep and yellow light hansa mixes, with a darker mix of Payne's gray and alizarin crimson for the trees closer to the foreground. When one-third dry, scratch in some tree structures with the Wonder knife. **Inset:** When the under-painting is dry, paint the highlights on the tree foliage by stippling mixes of Hooker's green deep, yellow orange azo and yellow light hansa with a little titanium white using the Derwentwater brush.

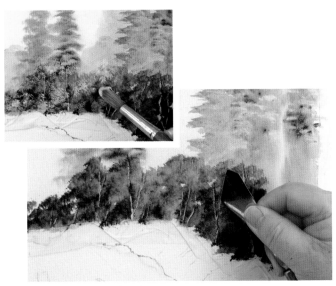

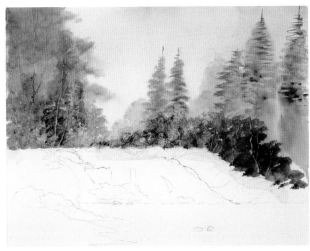

4. Foreground bushes

Rough out the bushes above the rock grouping on the right by stippling a Hooker's green deep and burnt sienna mix along the rock line. Scratch in some branch structures using the Wonder knife while the paint is still damp. **Inset:** When the paint is dry, lightly stipple in the lighter outer foliage, using mixes made from Hooker's green deep, yellow light hansa and titanium white.

6. Adding outer foliage

Continue stippling with the Derwentwater brush. using mixes from Step 4. Leave some of the dark values uncovered to indicate depth and shadows. **Inset:** When the paint is dry, carefully remove the masking tape. If you find you have pulled the tape off too quickly and it starts to tear the paper, remove it from the other edge.

5. Progress check

This is a good time to take a step back and assess your progress, before adding details to the foliage and starting to work on the foreground.

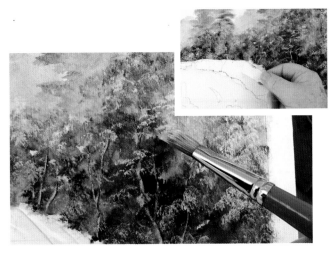

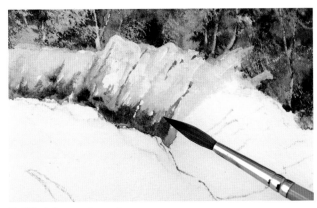

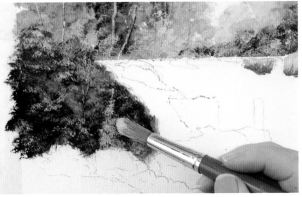

7. Wet-in-wet rocks

Now work on the rocks. Wet the rocks with a watery raw sienna and brush in light and dark values of a Payne's gray and alizarin crimson mix to suggest shadows and crevices. Use a pale raw sienna glaze on selected areas to add sparkle.

8. Adding contrast

Move to the left of the painting to add some more trees. Stipple in some darker tree shapes to the left of the waterfall. These contrast with those behind, making them appear to come forward. Paint a lighter bush with a pale mix to break the overall dark tone.

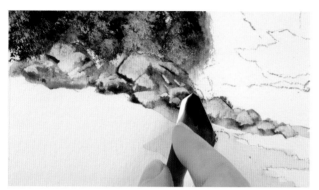

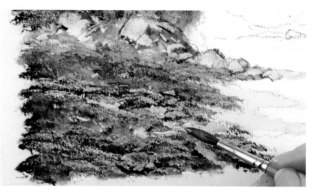

9. Foreground rocks

Continue to build the details with stronger mixes in the foreground. Use a raw sienna wash applied with the 20mm (¾ in) flat brush to shape the rocks on the left-hand side, and while still wet, paint some darker values with a Payne's gray and burnt sienna mix. Finally, use the Wonder knife to move paint and shape the rocks.

10. Developing the foreground

With the Ullswater brush and a variety of greens, both light and dark, paint the foreground vegetation with dabs of the brush to suggest clumps of foliage or moss-covered rocks. Add a few highlights using the Size 6 rigger brush.

11. Waterfall rocks

Using the rigger brush and raw sienna and burnt umber mixes, paint the rocks in the water. Use angled strokes to suggest where jagged edges break the water surface.

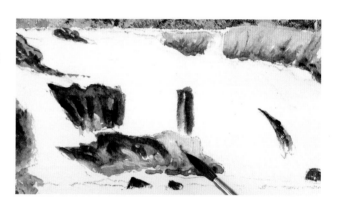

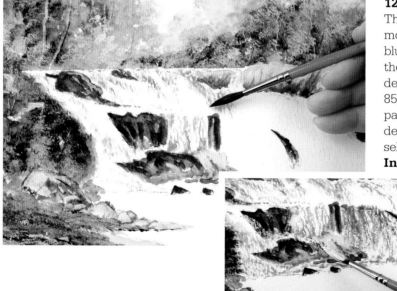

12. Falling water

This requires some sensitivity – less is more! Load the Size 6 rigger with a cobalt blue and alizarin crimson mix and using the side of the brush, stroke over the paper depositing paint on the peaks (see page 85). Stand back and decide where more paint is needed, continuing to add more depth to the water by over-painting selected areas with darker tones of the mix.

Inset: If you overdo it, go over it when dry with some titanium white, and use this to suggest splashes of water on the rocks, too. The important thing is to continually stand back and determine where over-painting may need correcting.

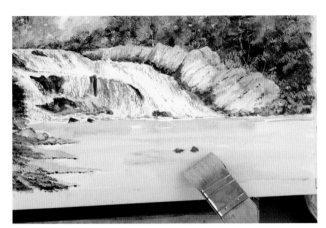

13. Foreground water
Now work on the water at the base of the waterfall. Apply a watery cobalt blue, followed by a weak raw sienna over the remaining area in the foreground, using the Sky and Texture brush.

14. Adding depth to the water
Using the side of the Size 14 round brush loaded with a dark Payne's gray and alizarin crimson mix, work inwards from both sides of the water to add depth. When dry, using the 20mm (¾in) flat brush, paint in titanium white to indicate ripples on the water, particularly at the base of the waterfall.

Useful Tip
Paint the rocks wet-in-wet using several colours. Let the colours blend together.

15. The finished painting
The waterfall is the main focal point of this painting, framed by the solid rocks and the background of soft trees. The waterfall and foreground water need a little patience and it is worth taking your time, frequently stepping back to assess your progress so that you don't overwork these areas.

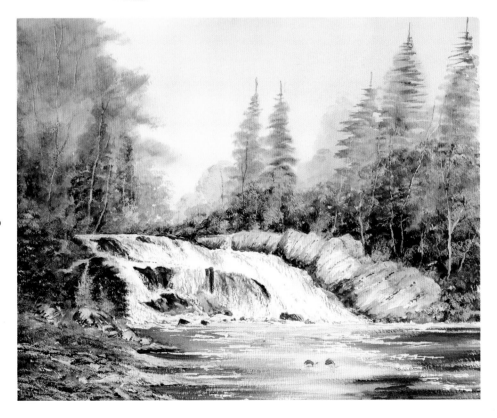

Project 6: Trees, Rocks and Running Water

ACRYLIC ON CANVAS

A river landscape may look daunting to the inexperienced artist, but if you can use a brush and follow the advice over the coming pages then you should be able to master it. The key to success when painting this type of scene is to think ahead – learn to paint it in simple stages, building up the stages in sequence.

Once you break the scene down, you can see how to piece together the painting – like you would a jigsaw – starting with the background of the sky and trees, before adding the detail of the foliage, and then the textured rocks and cascading water in the foreground.

In the Saturday Exercises we will learn how to build up the background tones, creating sky and trees. The Sunday Painting will bring the image to life, using sponge and brush to stipple in the foliage to add detail to this exciting three-dimensional impression. With a straightforward approach you will soon see how rewarding it is to paint this kind of landscape!

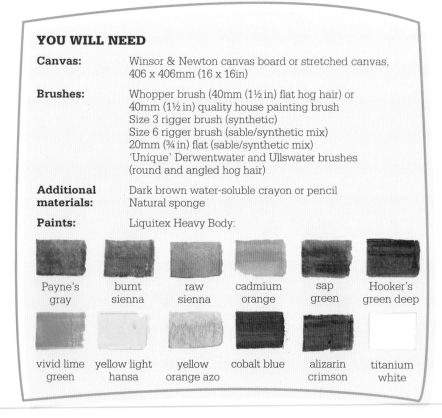

YOU WILL NEED

Canvas:	Winsor & Newton canvas board or stretched canvas, 406 x 406mm (16 x 16in)
Brushes:	Whopper brush (40mm (1½ in) flat hog hair) or 40mm (1½ in) quality house painting brush Size 3 rigger brush (synthetic) Size 6 rigger brush (sable/synthetic mix) 20mm (¾ in) flat (sable/synthetic mix) 'Unique' Derwentwater and Ullswater brushes (round and angled hog hair)
Additional materials:	Dark brown water-soluble crayon or pencil Natural sponge
Paints:	Liquitex Heavy Body:

Payne's gray	burnt sienna	raw sienna	cadmium orange	sap green	Hooker's green deep

vivid lime green	yellow light hansa	yellow orange azo	cobalt blue	alizarin crimson	titanium white

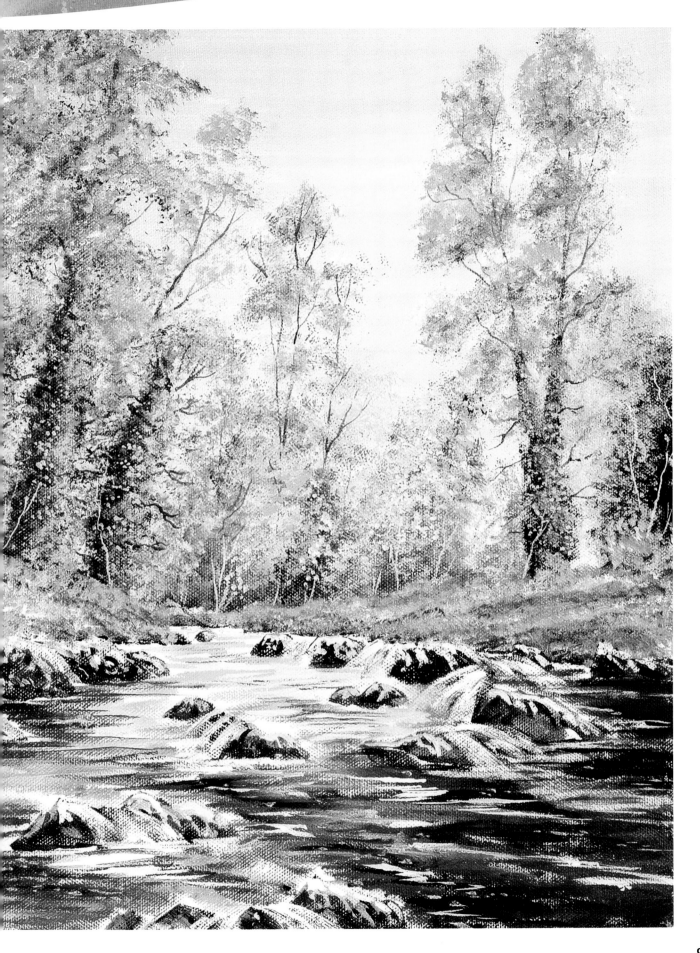

Saturday Exercises

PAINTING A SIMPLE BACKGROUND

It is important to be able to paint a simple background for landscapes when it supports more detailed features in the middle distance, such as the tree foliage in the Sunday Painting.

1. Under-painting
For the background sky, apply a cobalt blue and titanium white mix over the area using the Whopper brush. Use a lighter mix for the foreground.

2. Adding colour
Use a mix of cobalt blue, alizarin crimson and titanium white to create a soft purple, and brush this into the left-hand sky area.

3. Background trees
Stipple in the background tree shapes with the Derwentwater brush loaded with a mixture of Payne's gray, cobalt blue and titanium white. Make sure the mix is slightly darker than the sky tones, then allow to dry.

PAINTING TREES

I find trees a pleasure to paint. The watercolourist tells you to paint light to dark, but trees are dark on the inside with lighter foliage on the outside. Acrylic paints allow you to apply lighter tones over a darker under-painting.

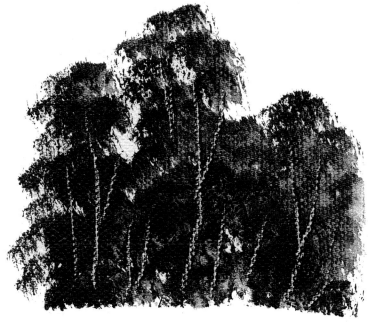

1. Inner foliage
To paint this group of trees, create the rough shapes by stippling with a Hooker's green deep and burnt sienna mix, using a round-ended hog hair brush. Here I have used my Derwentwater foliage and foreground brush and scratched in some tree structure using my Wonder knife.

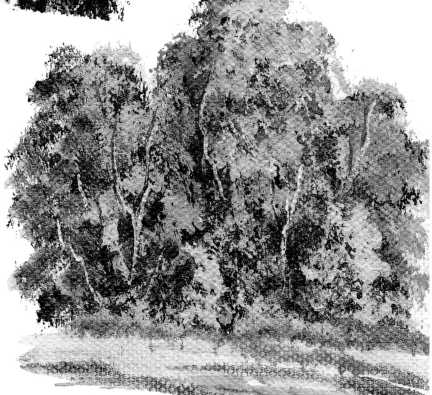

2. Fine leaf groupings
When the paint is dry, stipple in the varied tree foliage using combinations of yellow light hansa, yellow orange azo, cadmium orange, cadmium red and titanium white. Use a light stippling action to represent fine leaf groupings.

Useful Tip

Don't forget painting isn't a gift – practice makes perfect. Anyone can be taught to paint!

PAINTING LAND AND ROCKS

This exercise uses the technique of building up tones from dark to light to suggest the three-dimensional form of the land and rocks: a technique that can be applied to many landscape features. The dappled water helps to establish the scene.

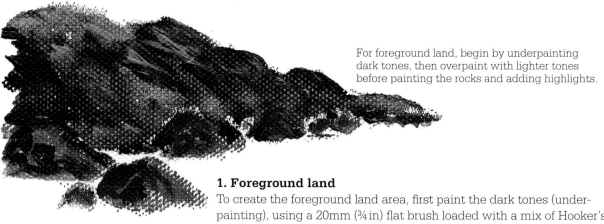

For foreground land, begin by underpainting dark tones, then overpaint with lighter tones before painting the rocks and adding highlights.

1. Foreground land

To create the foreground land area, first paint the dark tones (underpainting), using a 20mm (¾ in) flat brush loaded with a mix of Hooker's green and burnt sienna. Then over-paint with lighter values, using a middle tone green. Paint the rocks with a Payne's gray and burnt sienna mix. Use raw sienna to add highlights and structure.

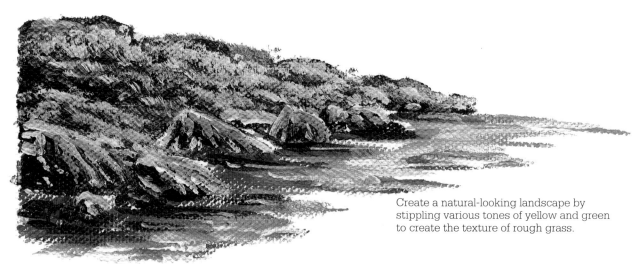

Create a natural-looking landscape by stippling various tones of yellow and green to create the texture of rough grass.

2. Creating depth

Using the Ullswater angled brush loaded with mixtures from yellow light hansa, yellow orange azo, Hooker's green deep and titanium white, stipple in various greens and yellows to create the texture of rough grass. The aim is to achieve a natural-looking landscape, with light and dark values to create interest. Overpaint the rocks using the Size 6 rigger brush loaded with a raw sienna and titanium white mix. Use a mix of Payne's gray and burnt sienna to paint the darker values to create a sense of depth at the waterline.

PAINTING FLOWING WATER

There's something enchanting and peaceful about flowing water, and to capture the effect in paint you simply need to break down the stages, using brushstrokes, tones and highlights to follow the flow and hopefully capture some of the serenity of the scene.

Water flowing between rocks

Representing water flowing between rocks isn't difficult. Simply paint the water using cobalt blue and add a little Payne's gray to the blue between the rocks. When it's dry, use the Size 6 rigger loaded with titanium white to paint in some white water flowing between the rocks. Angle your brushstrokes to create interest and realism.

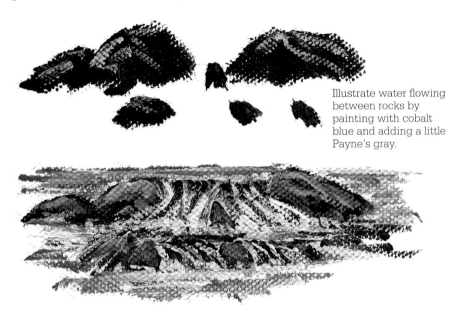

Illustrate water flowing between rocks by painting with cobalt blue and adding a little Payne's gray.

Brush in white water effects loading the brush with titanium white using the technique above.

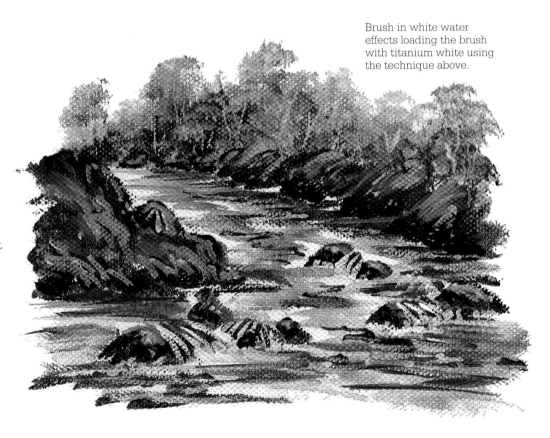

Fast-flowing water

To represent a fast-flowing river, apply cobalt blue with a 20mm (¾in) flat brush. When that is partially dry, load the brush with titanium white and brush in the effects of white water. Use the technique described above to paint the water flowing between rocks.

Sunday Painting

Trees and flowing water represent the landscape at its best – there's nothing more peaceful than sitting by a river listening to the sound of water lapping against rocks. If I'm lucky I may even be accompanied by the local dipper or duck. Although this landscape may look daunting to the less experienced artist, it is painted in simple stages, building up the elements in sequence.

See page 90 for a list of materials. Draw the outline of the composition with a water-soluble crayon, or transfer the outline following the instructions on page 11.

1. Background
Paint the background sky by brushing in a cobalt blue and titanium white mix with my Whopper brush or a 40mm (1½ in) house painting brush. Brush in a cobalt blue, alizarin crimson and titanium white mix on the left. Blend the two colours together.

2. Adding the distant trees
While the sky is still moist, stipple in some background trees. Add a little Payne's gray to darken the mix.

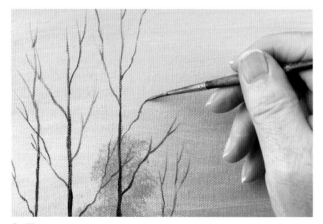

3. Tree structures
Using the Size 3 rigger brush loaded with a Payne's gray and burnt sienna mix, paint the tree structures working upwards from the ground, making the brushstrokes thinner towards the end of the branches.

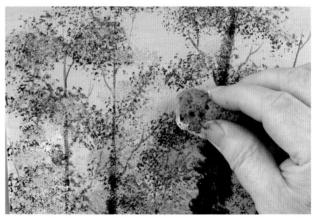

4. Tree foliage
Using a natural sponge, stipple in the background for the tree foliage using a sap green and burnt sienna mix. When it's dry, stipple in a variety of greens and oranges to represent foliage. Stipple lightly with the sponge to create the impression of small leaves.

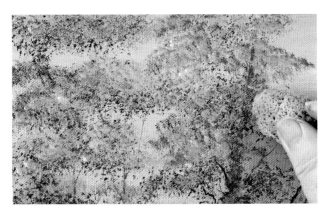

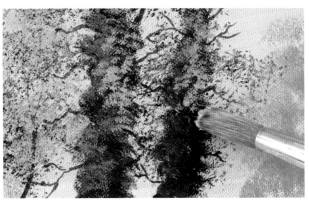

5. Developing the tree foliage

Continue sponging in the foliage using colour combinations mixed from yellow light hansa, yellow orange azo, vivid lime green, Hooker's green deep and titanium white.

6. Ivy on trees

Apply an under-painting of Hooker's green and burnt sienna to rough out the shapes of the ivy-covered tree trunks. Then over-paint with a vivid lime green to represent ivy.

7. Adding highlights

Add highlights to the ivy-covered trees using a pale green mixed from Hooker's green, yellow light hansa and titanium white. Use the Derwentwater brush to stipple on the representation of leaves, using a very light touch.

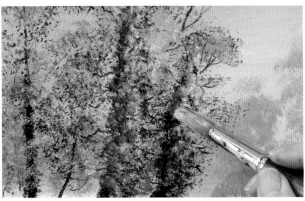

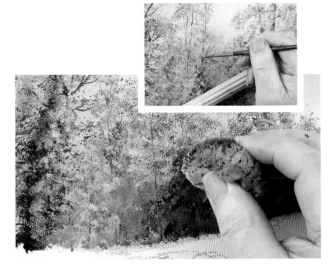

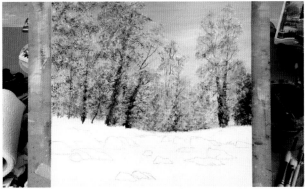

8. Building up the foliage

Working from left to right, continue to stipple in the foliage using a very light touch of the sponge.
Inset: Load the Size 3 rigger brush with a Payne's gray and burnt sienna mix. Support your hand with a dowel or mahl stick to paint the branches and twigs without smudging the under-painting.

9. Progress check

The simple background provides a plain support for the detailed trees and foliage.

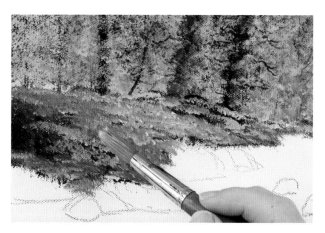

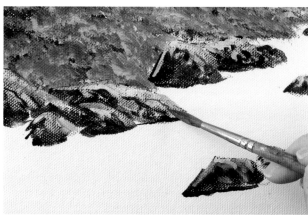

10. Riverbanks

Initially, use a 20mm (¾in) flat brush with a Hooker's green deep and burnt sienna mix to paint in the riverbank. When dry, stipple in greens, yellows and oranges using the Ullswater angled brush to represent the rough grasses and shrubs.

11. Rocks

Using the 20mm (¾in) flat brush loaded with a Payne's gray and burnt sienna mix, paint in the rocks. Then add highlights using mixes made from burnt sienna, raw sienna and titanium white.

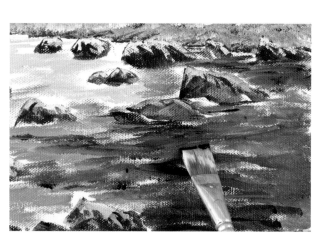

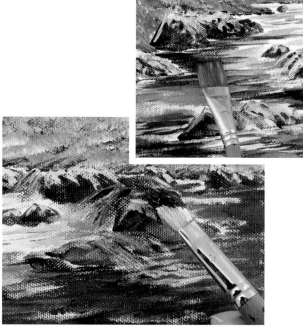

12. Water

Build up the water gradually using a 20mm (¾in) flat brush with a basic mix of cobalt blue and titanium white, with light values being painted in the distance graduating to darker values in the foreground, adding more cobalt blue to the mix.

Useful Tip

When painting water it is helpful to squint one's eyes to blur the image. This helps to determine the flow patterns.

13. Flowing water

Using the Ullswater brush, brush in dark tones between the rocks to indicate water tumbling over and between them. When dry, load a clean brush with titanium white and use quick twitches to deposit paint to represent white water. **Inset:** Add a little Payne's gray to the mix to paint the shadows from the bank, working inwards from both sides of the bank.

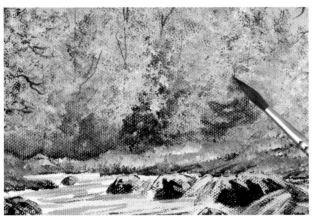

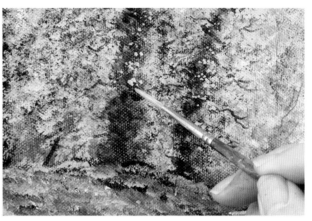

14. Adding depth

Continue to work on the trees, adding dark tones to the foliage to give a sense of depth. Apply a Payne's gray and alizarin crimson mix with the rigger brush. Simply dab on paint and wiggle it around to spread it over the foliage, to create realistic depth.

15. Looking at detail

Using the fine rigger, add a few dabs here and there with a light green mix to add detail to the foliage.

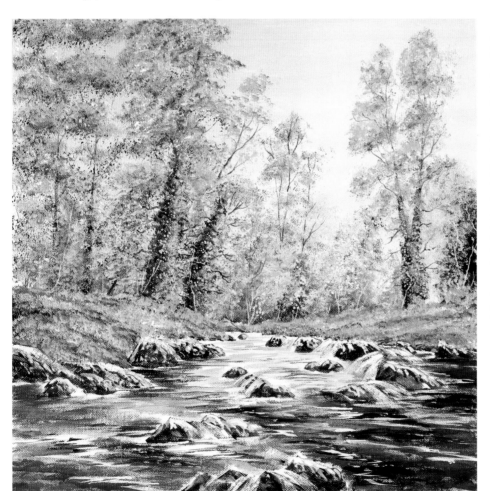

16. The finished painting

This is the stage where a final sense of unity needs to be brought to the painting. To achieve this I take a critical look at my paintings, and add the further detail I feel the painting needs. Here, I would consider improving the colours in the foliage, refining form and adding highlights in the foliage and land areas. A few white ripples in the water and a few branches in the tree structures may also be added.

Gallery Exercise – 'Storm Clouds'

ACRYLIC WATERCOLOUR

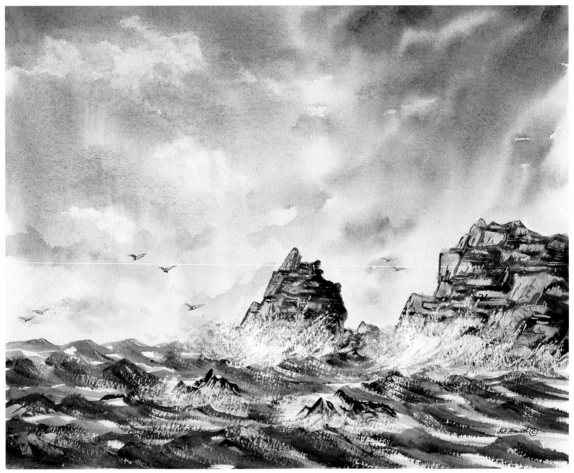

Paints:

| Payne's gray | cobalt blue | alizarin crimson | raw sienna | burnt sienna | Hooker's green deep |

Considerations:

- Paint a variety of blues and purples in the sky to suggest stormy weather.
- Use an absorbent tissue to blot out the cumulonimbus rain clouds.
- Tilt the board and let the wet paint run downwards to create atmospheric conditions.
- Make the rocks colourful using variations of similar tones, with brighter areas.

How it was painted:

- Sky – Wet-in-wet, tilting the board to let the paint run down to water level and dabbing in the white clouds.
- Rocks – Using the 20mm (¾in) flat brush, a raw sienna wash was applied to form the rocks followed by some burnt sienna, then a Payne's gray and alizarin crimson mix. The structure of the rocks was created using the Wonder knife.
- Sea – Curved strokes of the 20mm (¾in) flat brush created the impression of waves. A little Hooker's green deep was added to the cobalt blue.
- Waves lashing rocks – A white water-soluble crayon was soaked until soft and the side of the crayon rubbed upwards to deposit the white on the rocks.

Techniques:

- Wet-in-Wet Sky with Cumulus Clouds, page 36.
- Rocks Using a Palette Knife, page 106.
- Impressions of Water, page 107.

Paper:

Saunders Waterford (Rough) 640gsm (300lb), 380 x 280mm (15 x 10in)

Gallery Exercise – 'Seascape'

ACRYLIC ON CANVAS

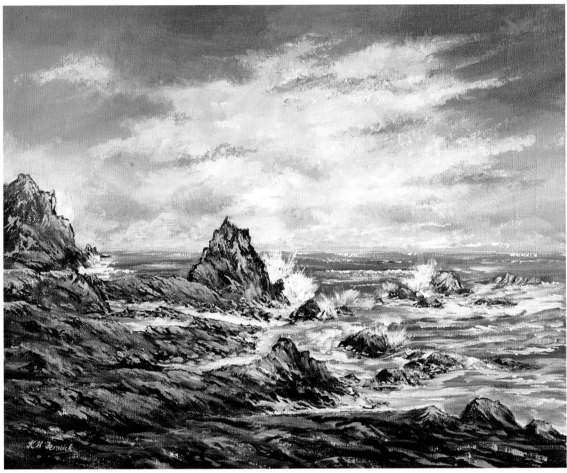

Paints:

| Payne's gray | cobalt blue | alizarin crimson | raw sienna | burnt sienna | titanium white | Hooker's green deep |

Considerations:

- The positioning of the cliffs and rocks to make a pleasing composition.
- The waves lashing the rocks.
- The wide range of colours in the rocks.
- The water channels that help shape the composition.
- The varied flow patterns of the sea and the position of the white water lashing the rocks.

How it was painted:

- Sky – The white clouds were painted to match the white of the surf.
- Cliffs and rocks – A raw sienna under-painting was applied with the 20mm (¾in) flat brush to shape the rocks. This under-painting was then brushed over with many colours: burnt sienna; alizarin crimson; Payne's gray and alizarin crimson mixes and a little Hooker's green deep here and there.
- Smaller rocks – Note the smaller rocks situated at the base of the larger rocks where the water is flowing in the various channels – a few hours before I had been sitting there on the sandy beach.

Techniques:

- Sea and Waves, page 49.
- Rocks, page 51.
- Simple Background Sky, page 92.

Canvas:

Winsor & Newton stretched canvas, 610 x 510mm (24 x 20in)

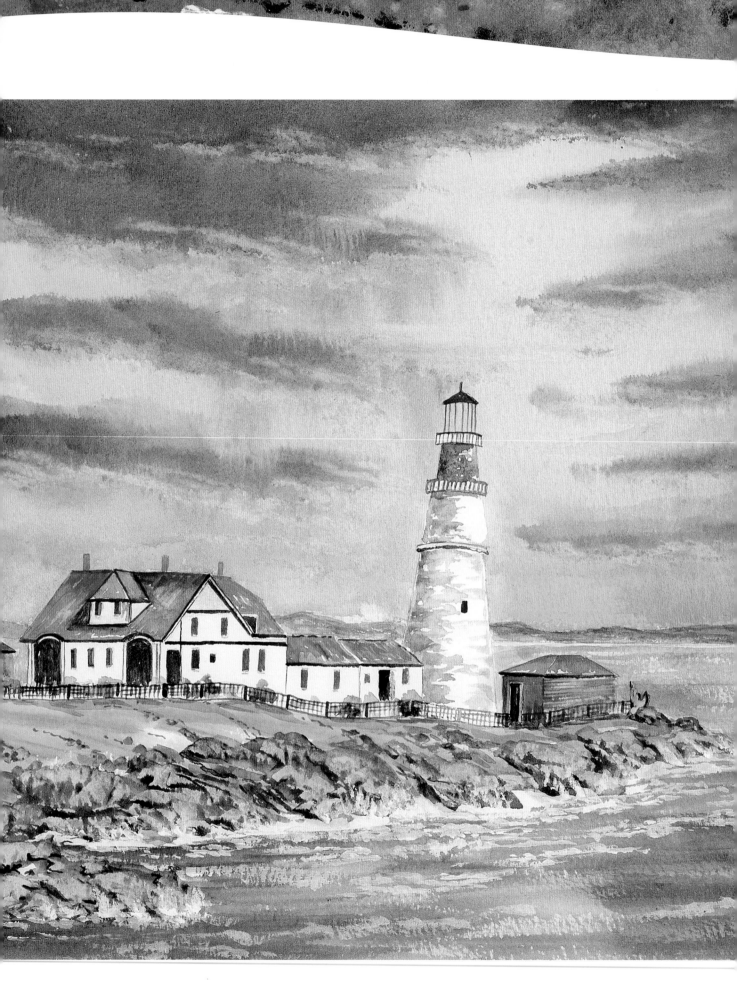

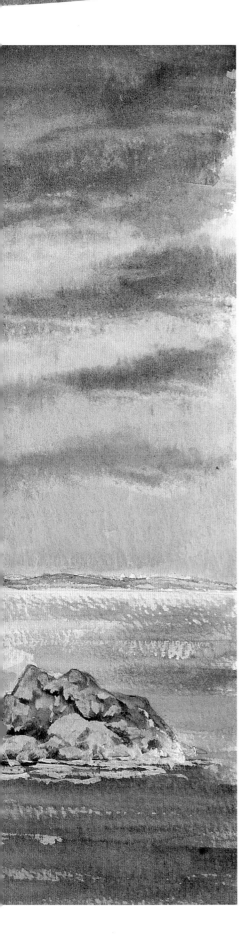

Project 7: Sky, Rocks and Sea

ACRYLIC WATERCOLOUR

The famous Portland Head Lighthouse in Maine makes a dramatic subject. The sky is a key feature and I will show you how to render an evening sky using glazes and wet-in-wet blending in the Saturday Exercises. You will also have the opportunity to practise the techniques required for a group of buildings, based on your experience of using masking to preserve their shapes.

The special technique of using the Wonder knife to create the rocks is demonstrated here, together with exercises for rendering the changing surface of the sea.

You will then have the confidence to bring all these elements – a warm evening sky, lighthouse buildings, rocks and a calm sea – together in the Sunday Painting.

You will need

Paper:	Saunders Waterford (Rough) 640gsm (300lb), 380 x 280mm (15 x 11in)
Brushes:	Old Size 6 rigger for applying masking fluid Sky and Texture brush (40mm (1½in) hake) 20mm (¾in) flat (sable/synthetic mix) Size 6 rigger (sable/synthetic mix) Size 3 rigger (synthetic) 20mm (¾in) mop brush
Additional materials:	Dark brown water-soluble crayon or pencil Masking fluid Absorbent tissues Hard eraser Wonder knife or palette knife White water-soluble crayon
Paints:	Liquitex Heavy Body

Payne's gray cobalt blue alizarin crimson raw sienna

burnt sienna titanium white cadmium orange

Saturday Exercises

PAINTING AN EVENING SKY

A colourful evening sky can add interest to your painting, and acrylic paints are ideal for this, as it is easy to build up the colours using glazes while wet-in-wet techniques allow the colour to merge and blend naturally.

1. Warm tone under-painting
To establish the warm tone of the sky, brush in an even wash of raw sienna with the Sky and Texture brush.

> ### Useful Tip
> **Try brushing a glaze over an off-cut of paper first until you are happy with the depth of colour.**

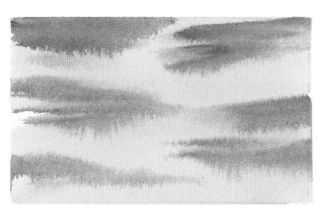

2. Blue tone clouds
While the paint is still wet, add some cobalt blue clouds using the chisel edge of the Sky and Texture brush. Keep the cloud shapes linear, with some breaking the edge of the paper. Working quickly while the paint is still wet, brush in a cobalt blue and alizarin crimson mix to darken the clouds at the top of the sky. Allow the paint to dry completely.

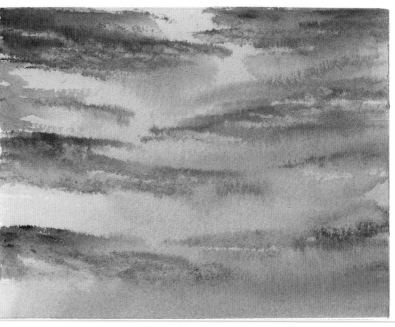

3. Adding warm tones
For the warmth of an evening sunset, apply some orange-red tones wet-in-wet. Mix a touch of raw sienna with a touch of yellow orange azo and glaze the whole of the sky area. While the paint is still very wet, add some alizarin crimson to the brush and brush over selected areas of the sky to create a warm glow, especially in the lower part nearer to the horizon.

PAINTING WEATHERED BUILDINGS

Coastal buildings – fishermen's cottages, boat yards, hotels, lighthouses – often take the brunt of the weather from the sea and it is useful to know how to render the resulting uneven, patchy surfaces of paint and stonework. Here, I show you how to use masking fluid and how to lift off colour to create this effect.

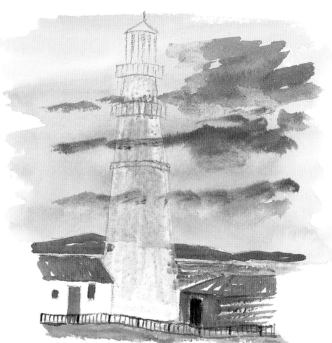

1. Masking off
Draw the tower then cover it with masking fluid. Make sure the masking fluid is completely dry and then paint in the sky (see opposite). Don't worry about washing over the tower, that's the reason the masking fluid was applied – to preserve the white of the paper. Once the paint is dry, remove the masking with a hard eraser, restoring the white of the paper.

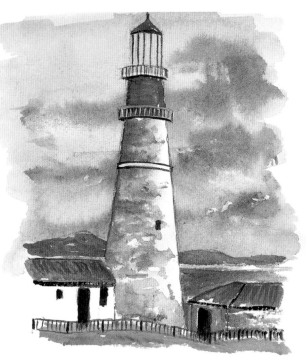

2. Weathered effect
To paint the weathered effect on the main body of the lighthouse tower, wet it all over with clean water. While it is still wet, drop in some raw sienna with the Size 6 rigger and move the paint around to create a ragged effect. Add a cobalt blue and alizarin crimson mix and drop in this darker colour on the left-hand side of the tower. The colours will blend together. Use the point of a crumpled tissue to lift off areas of paint to create the desired effect of weathered stonework.

PAINTING ROCKS USING A PALETTE KNIFE

On this page, I'm going to show you how easy it is to create cliffs, rocks and mountains by simply moving paint with a palette knife. In these examples, I have used my Wonder knife (see page 15), which is also wonderful for painting stone walls and creating weathering of stonework on old buildings. I cannot create these effects with a brush and it is so easy.

Receding cliffs

To create this group of cliffs, just splash paint on all over (that's a technical term!) and move it around with the Wonder knife – it's just like buttering your bread. Use the rigger brush loaded with a dark Payne's gray and alizarin crimson mix to paint shadows on one side of the rocks to achieve a three-dimensional effect. When you are painting outdoors, you can choose the appropriate colours and move paint to capture the actual shape of the rock face.

Group of rocks

Start with a raw sienna wash, then drop in some burnt sienna and a darker mix made from Payne's gray and alizarin crimson to establish the basic shapes. When the paint is approximately one-third dry (when the shine is starting to go off), apply the Wonder knife to give form to the rocks.

Mountain face

These two examples representing mountain structures were created the same way. I have used the point of the knife to create the strata and the edge or side of the knife to depict the larger rock formations.

PAINTING IMPRESSIONS OF WATER

The following examples are intended to be quick and clever ways to achieve a realistic effect, or impression, of the water surface; they are certainly not meant to be masterclass standard seascapes. With a light touch of your brush you can achieve some wonderful effects.

Light on water

This is a similar exercise to that on page 85, and is useful for you to practise creating sparkle on water by leaving the paper surface uncovered in parts. Brush the paint gently across the surface of the paper, covering the peaks of the paper and not the valleys – leaving the white of the paper uncovered to represent light on the water.

> ### Useful Tip
> To paint the impression of waves splashing against rocks, dip your finger in white paint and twitch upwards.

Wave forms

Using a 20mm (¾in) flat brush, use curved strokes of the brush to represent wave forms. Initially, shape the waves with a pale cobalt blue, over-painted with a cobalt blue and Hooker's green deep mix, leaving some of the first wash showing through, and finally paint in darker tones of this mix to highlight the peaks of the waves. Note how some of the white of the paper is left uncovered.

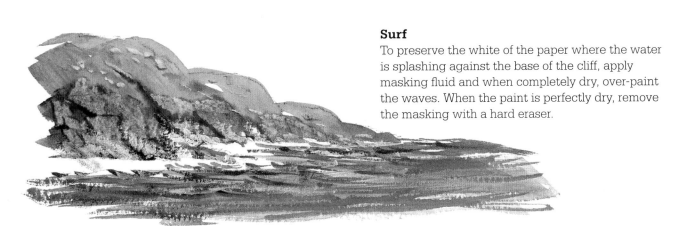

Surf

To preserve the white of the paper where the water is splashing against the base of the cliff, apply masking fluid and when completely dry, over-paint the waves. When the paint is perfectly dry, remove the masking with a hard eraser.

Sunday Painting

I think you'll enjoy this painting – it brings together several techniques and is a useful exercise in a different type of sky. With a calm, shimmering sea in the foreground, the Portland Head Lighthouse stands out against the warm sunset.

See page 103 for a list of materials. Begin by drawing the outline using a water-soluble crayon or pencil, or alternatively transfer the outline following the instructions on page 11.

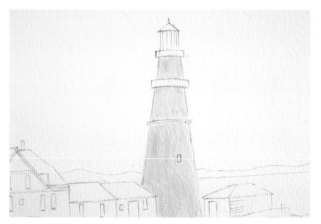

1. Masking the tower
Draw the outline of the composition taking care to draw the tower in proportion to the rest of the buildings. Use an old brush to apply masking fluid to the whole of the tower.

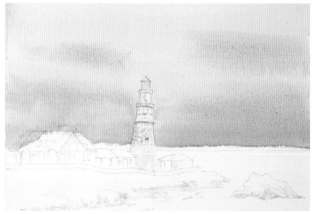

2. Laying in the sky
Paint the sky with a watery raw sienna wash using the Sky and Texture brush, adding a little cadmium orange as you approach the horizon. Paint over the masked tower.

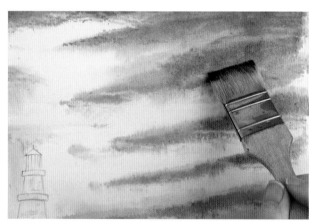

3. Cloud formations
With a mix of Payne's gray, cobalt blue and alizarin crimson, paint the cloud formations with the edge of the Sky and Texture brush. Use a tissue to control the flow of paint and also to shape the clouds.

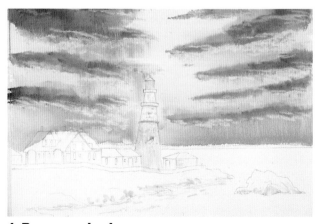

4. Progress check
At this stage of the painting the sky and clouds are established, with the clouds receding towards the horizon and a warm undertone over the whole sky.

> **Useful Tip**
> When applying masking fluid, keep rinsing the brush between applications to avoid the masking fluid drying on the brush.

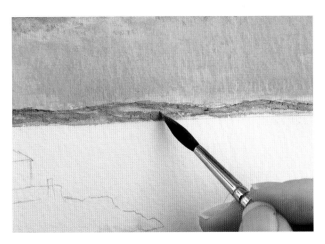

5. Distant hills
Using the Size 6 rigger brush loaded with a mix of Payne's gray, cobalt blue and alizarin crimson, add the line of the distant hills across the horizon. Add a little cobalt blue and titanium white mix to soften them.

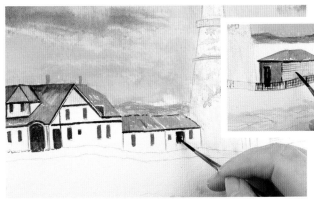

6. Adding buildings
Paint in the buildings using a burnt sienna and alizarin crimson mix for the roofs and a Payne's gray and alizarin crimson mix for the windows, doors and other details using the Size 3 rigger brush. **Inset:** To paint the woodwork of the right-hand building, use a raw sienna and burnt sienna mix. Allow it to dry, then use the rigger brush to paint in the lines between the planks and the fence that runs the length of the buildings.

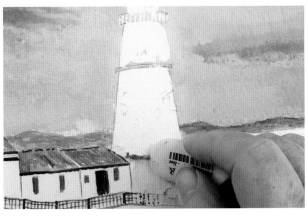

7. Removing masking fluid
Remove the masking from the tower when the paint is perfectly dry, using a hard eraser.

8. Wet-in-wet weathering effects
First wet the tower with clean water then brush in raw sienna, followed by a cobalt blue and alizarin crimson mix on the left-hand side. Painting wet-in-wet allows the colours to blend together. Control the flow with a tissue shaped to a point.

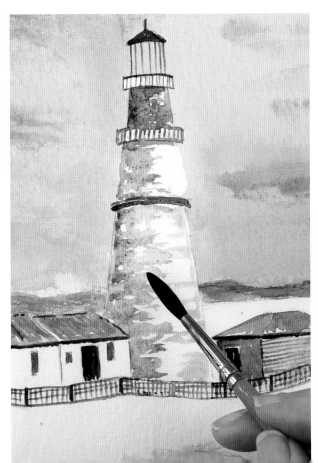

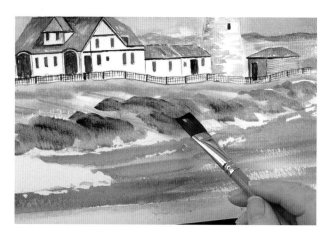

9. Adding foreground

Paint in the sea with a watery cobalt blue and alizarin crimson wash using the 20mm (¾in) mop brush. Allow the paint to dry completely. Next, paint the soft green grass on the headland followed by the rocks in mixes of raw sienna and burnt umber. Over-paint selected areas with a Payne's gray and alizarin crimson mix. Note, I have not painted right up to the water level but left some white paper uncovered.

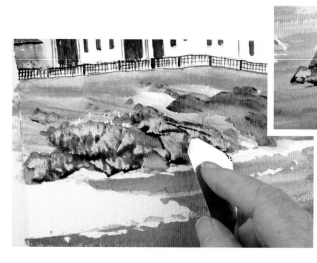

10. Shaping rocks

Start to add detail to the rocks. Using the Wonder knife, move the paint around to shape the rocks, with paler areas following the rounded form (see page 106). **Inset:** Using the same colours and techniques, paint the right-hand rock, shaping it with the Wonder knife.

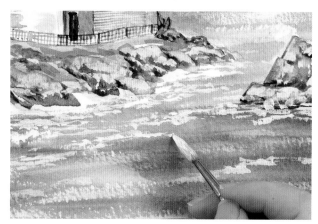

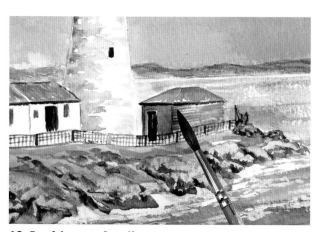

11. White water

Next, work on the sea. Wiggle the Size 6 rigger loaded with titanium white, to achieve an impression of waves and white water. Paint white water at the base of the right-hand rock where the waves splash against it.

12. Looking at detail

Continue to build up detail across the painting. Using the Size 6 rigger brush, apply a further wash of raw sienna over the right-hand wooden building to create more depth.

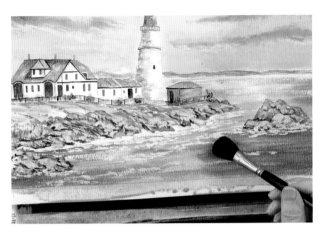

13. Applying a glaze

Take a moment to assess your progress. I felt the need to add more colour and an indication of depth in the foreground sea. To achieve this, apply a Payne's gray and alizarin crimson glaze with the mop brush to create a middle tone purple. When completely dry, apply a weak raw sienna wash to represent reflections from the sky.

> ### Useful Tip
> Use a palette knife to move wet paint to create the impression of rocks.

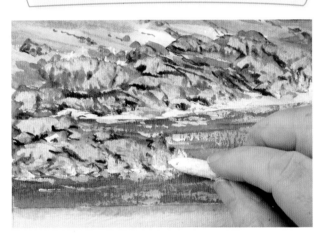

14. Sea spray

Although this is not meant to be a stormy sea, I have applied a wet white water-soluble crayon to the base of the rocks, to represent spray. This is a useful technique but I could also have used titanium white paint. Dip the crayon in water until it softens and flick it upwards to leave a white deposit, which will create realistic effects.

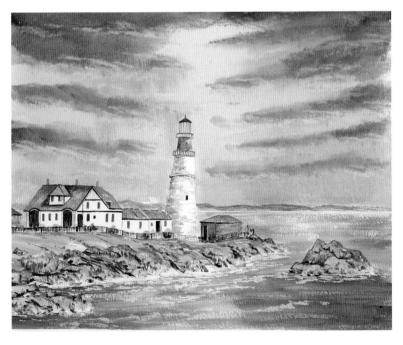

15. The finished painting

The rocks are important in this composition and I gave them further attention by using the rigger brush loaded with a Payne's gray and alizarin crimson mix (the shadow colour) to darken the fissures in the rocks created with the palette knife. It is surprising the difference it makes. Don't forget, if you aren't happy with the end result you can lighten or darken areas in your work by over-painting and then painting them again. That's the advantage of acrylics.

Project 8: Springtime

ACRYLIC ON CANVAS

Springtime embraces the landscape with bright, clean colour. This project is a wonderful exercise in colour mixing and introduces some different mixes to your palette. Alongside the spring foliage, I have taken elements of the scene to expand your repertoire of landscape features, with tips on reflecting foliage colour in water by dragging the paint across the canvas.

The Saturday Exercises provide a lesson in drawing the picturesque bridge and I will show you how to paint stonework – a technique that can be applied to other walls and buildings. You will learn how to master the fast-flowing stream and riverbanks, looking at shapes and shadows to convey realistic impressions with ease.

The Sunday Painting brings these features together, using the new techniques and giving you the opportunity to build on those that you have already learned.

You will need

Canvas:	Winsor & Newton canvas board or stretched canvas, 406 x 406mm (16 x 16in)
Brushes:	Whopper brush (40mm (1½in) quality house painting brush) 'Unique' Derwentwater and Ullswater brushes (round and angled hog hair) Stippler (25mm (1in) high quality house painting brush) Size 3 rigger (synthetic) 40mm (1½ in) flat brush (hog hair) 20mm (¾ in) flat brush (sable/synthetic mix)
Additional materials:	Dark brown water-soluble crayon or pencil Wonder knife (or palette knife) Piece of card
Paints:	Liquitex Heavy Body

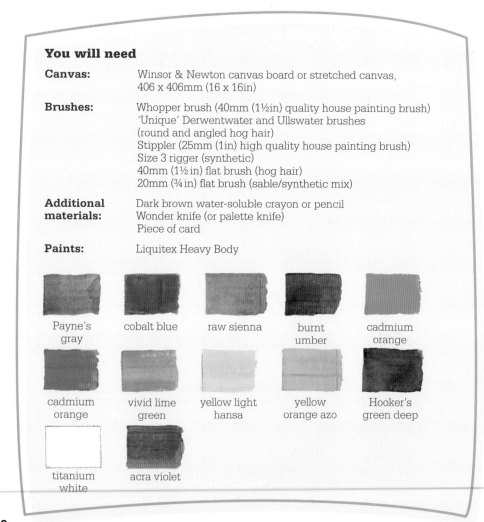

Payne's gray cobalt blue raw sienna burnt umber cadmium orange

cadmium orange vivid lime green yellow light hansa yellow orange azo Hooker's green deep

titanium white acra violet

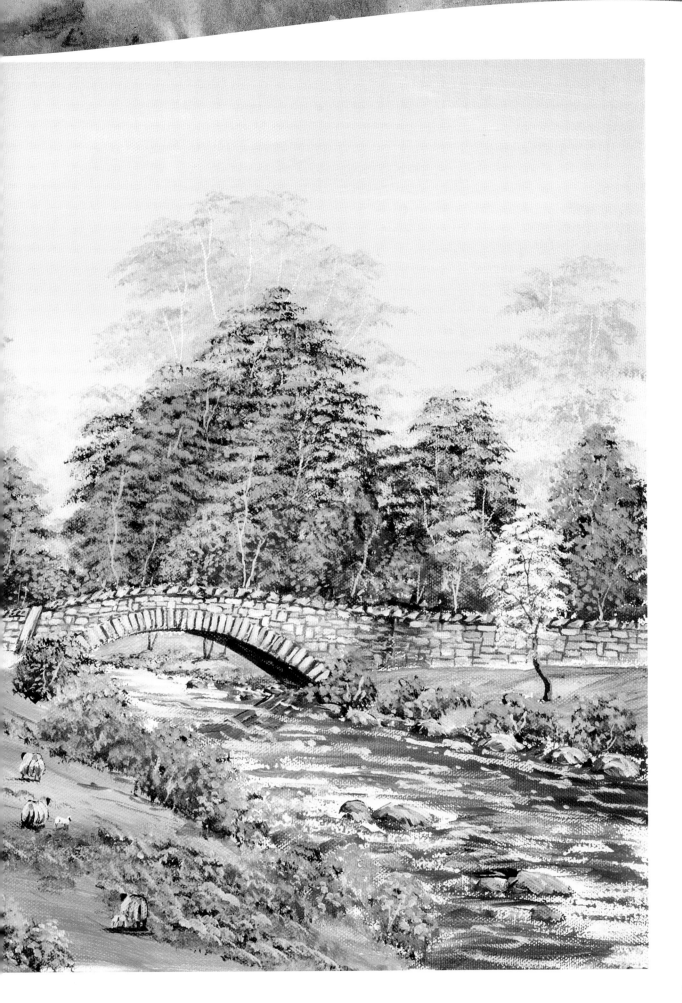

Saturday Exercises

PAINTING A BRIDGE

When including a bridge in your composition, always view it from a position where you can see some of the underside of the arch – it makes a much more pleasing representation.

1. Under-painting the structure
Having drawn the bridge, paint the stonework with a raw sienna and titanium white mix and the underside of the arch a Payne's gray and burnt sienna mix. Note the shape of this area in shadow and the angle at ground level.

2. Painting stonework
When the paint is dry, draw in the shape of the stones and those making up the arch, using the Size 3 rigger brush loaded with a Payne's gray and burnt sienna mix.
For better control of the brush, rest your hand on the canvas to help you with the finer lines.
To provide variety in the stone colours, use cobalt blue and alizarin crimson mixes. Lighten some stones with a titanium white and raw sienna mix.

PAINTING TREE COLOUR AND REFLECTIONS

The beauty of tree foliage in the spring never fails to excite me. The vibrant, fresh colours used here introduce a few new colours to your palette.

1. Establishing shape
Use a few brushstrokes to represent the underlying branch structure, then stipple in the rough tree shapes and land areas using the Derwentwater brush with a mix of Hooker's green deep and burnt sienna.

2. Colour mixes
With a clean brush and mixes of cadmium orange, acra violet, cadmium red, yellow orange azo and titanium white, stipple in the tree foliage. Use a brush well loaded with paint and stipple lightly to deposit paint in clusters to represent foliage.

3. Reflections
Paint the water with a cobalt blue and titanium white mix and while still wet, drag the tree colours downwards using a 20mm (¾in) flat brush to produce reflections. Hold the brush close to the canvas and pull downwards before lifting. Add a few wind lines using titanium white to 'break' the surface of the water.

PAINTING RIVERBANKS

Riverbanks are a fascinating subject to paint – they are never a uniform shape. Don't forget to shape the banks to improve the composition; you are not painting a man-made waterway, such as a canal.

Riverside vegetation
To add interest to the bank of this snow scene, I have painted some reeds and tufts of coarse grass by loading a hog hair fan brush with Payne's gray and flicking upwards to create an impression of reeds. When this was dry, the brush was cleaned and loaded with a titanium white and cobalt blue mix and the reeds over-painted to represent snow and frost deposits.

> ## Useful Tip
> Remember when painting a riverbank that it is not a regular, straight shape.

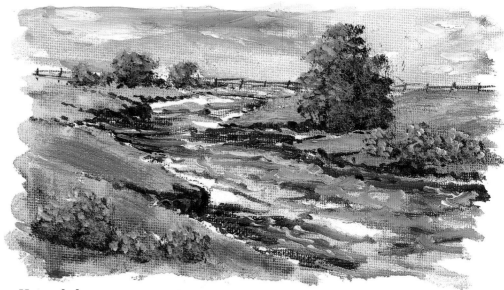

Natural shapes
Here, I have shaped the riverbanks and used linear perspective to lead the eye into the distance. On the left-hand bank in particular, I have shown areas where the water has washed parts of the bank away. This has helped to shape the bank and make it appear much more natural. Use darker values to give definition to the riverbank, providing distinction between the land and water.

PAINTING RUNNING WATER AND ROCKS

This is a simple exercise for you to practise painting flowing water, using tonal values to give the impression of depth and movement.

1. Under-painting

Using a 20mm (¾ in) flat brush, brush in the under-painting using a pale titanium white and cobalt blue mix for the distant water and as you move forward, darken the value by adding more cobalt blue to the mix.

2. Bank shadows

The next stage is to paint in some shadows near the banks using a cobalt blue and alizarin crimson mix. This is important to make the bank more distinctive and to give more depth to the water. If this darker value is not added the water will appear undefined. Using the rigger brush loaded with titanium white, brush in some flow patterns (wiggly lines) to create the impression of fast flowing water.

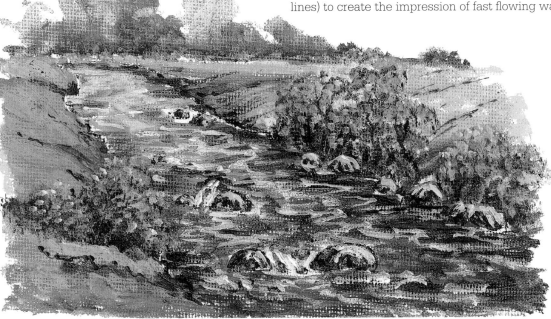

3. Defining the rocks

Paint the rocks with the flat brush, applying an under-painting of burnt sienna and raw sienna, with a Payne's gray and burnt sienna mix for the dark areas, which gives the rocks a three-dimensional look. Using the rigger brush loaded with a titanium white and raw sienna mix, add some highlights to the rocks.

Sunday Painting

It's springtime, the blossom is in full bloom, the sheep and their lambs graze peacefully on the riverbank. With a palette of spring colours and the challenge of a beautiful stone bridge, this painting brings together many techniques that you'll enjoy mastering.

See page 112 for a list of materials. Begin by drawing the outline using a water-soluble crayon or pencil, or alternatively transfer the outline following the instructions on page 11.

1. Establishing the background
With the Whopper brush and a mix of raw sienna, alizarin crimson and titanium white, paint an even-toned background down to the bridge.

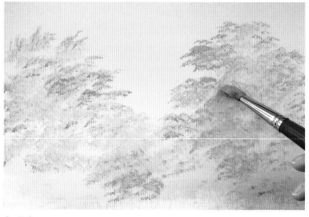

2. Distant trees
Paint in the distant tree shapes by stippling in a cobalt blue and titanium white mix with the Ullswater brush, using the tip of the brush with a light touch to suggest the leaf masses.

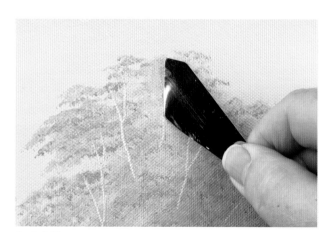

3. Adding tree structures
Using the Wonder knife, scratch in a few tree structures, using the shape of the foliage to help position the trunks and branches.

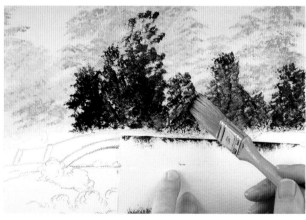

4. Building the middle distance
Paint the rough shapes of the trees behind the bridge by stippling with the 25mm (1in) Stippler loaded with a Payne's gray and Hooker's green mix. To protect the shape of the bridge, use a piece of card as a mask.

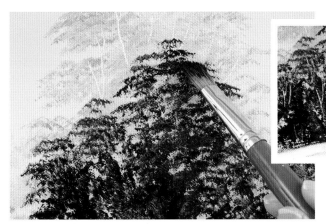

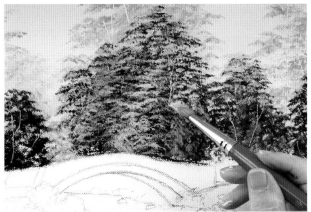

> ### Useful Tip
> Treat each tree as an individual, although part of an overall grouping.

5. Refining tree shapes
Continue to work on the mid-ground trees, using the Ullswater brush to refine the shapes of the outer foliage. **Inset:** Use the Wonder knife to scratch in some tree structures.

6. Tree colour
With the darker, inner structure of the trees established, continue with the Ullswater brush, stippling paint to represent the blossom using various mixes made from yellow orange azo, cadmium orange, cadmium red light, acra violet, cobalt blue, vivid lime green and titanium white. Continue to work across the painting.

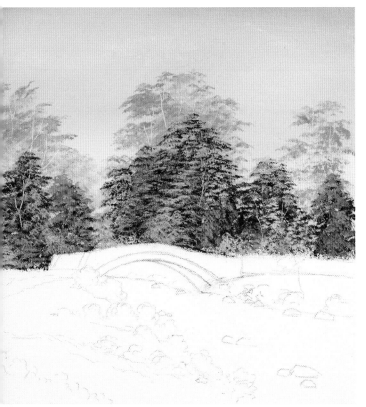

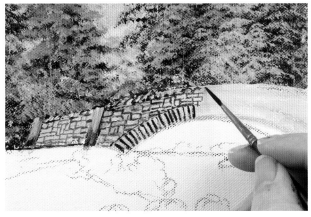

7. Progress check
At this stage of the painting the background and middle distance have been established, with the faint, shadowy forms of the background trees already giving a sense of distance to the scene.

8. Developing the bridge
Next, work on the bridge, establishing a warm stone colour with a mix of raw sienna and titanium white over the whole bridge. Speed up the drying time with a hairdryer if necessary, then start to define the shape of the stonework with a Size 3 rigger loaded with burnt umber.

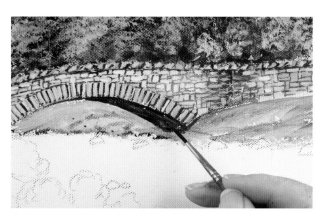

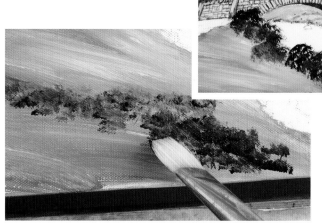

9. Adding the underside of the bridge

Using the 40mm (1½ in) flat brush, start to paint the grass bank with a vivid lime green and raw sienna mix. Using the rigger brush, paint the underside of the bridge arch with a Payne's gray and burnt umber mix, using a rich application of paint to achieve a solid tone.

10. Building foreground detail

Using the same grass mix as in Step 9, work across the left-hand bank. To create rough grasses, stipple in the same mix with the addition of Hooker's green. **Inset:** Using this darker mix, paint the shapes of the bushes on the left-hand bank.

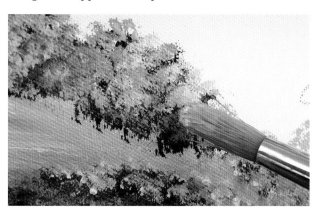

11. Bankside blossom

When the paint is completely dry, use the Derwentwater brush and work along the bank, painting the colours of the blossom using various mixes made from yellow orange azo, yellow light hansa, cadmium orange, acra violet, cobalt blue and titanium white.

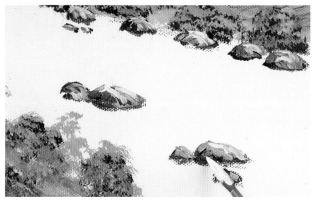

12. Establishing the path

Continue to work on the foreground. Add the background colour to the path with an under-painting of raw sienna and titanium white. Brush in a mix of cobalt blue and Payne's gray to give the path a textured appearance.

13. River rocks

Next, work on the river, establishing the mid-stream rocks with the 20mm (¾ in) flat brush, initially loaded with raw sienna and over-painted with burnt umber to achieve a three-dimensional effect. Brush in highlights with a raw sienna and titanium white mix using the Size 6 rigger brush.

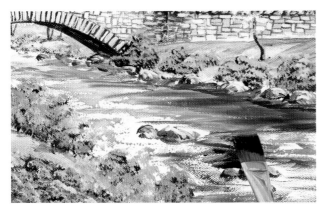

14. Flowing water

Use the 20mm (¾ in) flat brush to apply titanium white with a little cobalt blue in the background. Add more cobalt blue towards the foreground and Payne's gray for the darker tones near the banks. Mimic the eddies with your brush and add highlights around the rocks.

15. Spring blossom

Using the small rigger brush loaded with appropriate colours (see Step 11), refine the blossom where necessary. Dab on paint in small deposits to soften the effect.

16. Finishing touches

To add life to the painting, paint a few sheep and spring lambs dotted along the riverbank. See page 27 for the techniques.

> **Useful Tip**
> When painting a bridge, always show some of the underside of the arch.

17. The finished painting

I never complete a painting in one sitting. I prefer to look at it over several days and make any changes I consider necessary. These may be to add highlights on the grass banks, a few extra wiggles in the water to indicate fast flow or shadows painted into the trees to give depth. Some would tell you not to pick or fiddle but to me these little changes make all the difference to the final painting.

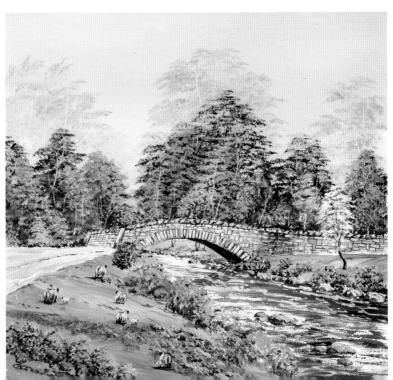

Gallery Exercise – 'Reflections'

ACRYLIC WATERCOLOUR

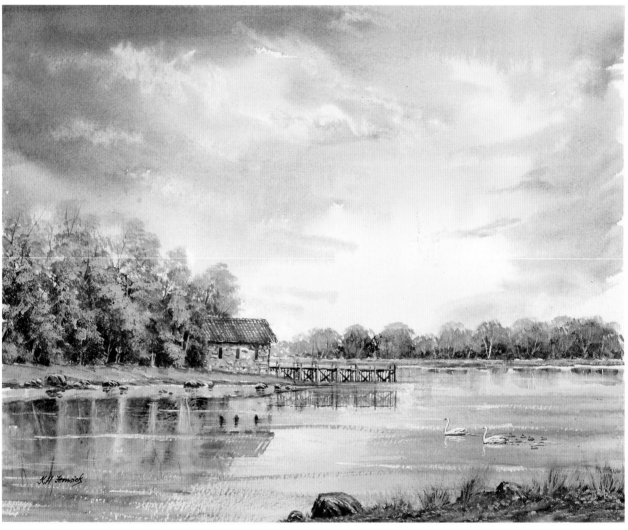

Paints:

| Payne's gray | cobalt blue | alizarin crimson | raw sienna | Hooker's green deep | yellow light hansa | burnt sienna | titanium white |

Considerations:

- Position the horizon line one-third of the way up the paper.
- Add a little blue to the green of the distant trees to give a sense of recession.
- Use vertical strokes with the 20mm (¾ in) flat brush for the reflections.
- Use a mask or masking tape to keep the water line level.

How it was painted:

- Sky – Wet-in-wet with a hake brush under-painting and when less than one-third dry, cobalt blue brushed in. Cloud formations created by dabbing with a tissue.
- Trees – Various greens stippled in, using the Derwentwater brush.
- Building and landing stage – Painted with 20mm (¾ in) flat brush.
- Swans – See page 26.

Techniques:

- Wet-in-Wet Sky, page 36.
- Tree Grouping, page 62.
- Foreground Water, page 85.
- Impressions of Water, page 107.

Paper:

Saunders Waterford (Rough) 640gsm (300lb), 380 x 280mm (15 x 11in)

Gallery Exercise – 'First Snow'

ACRYLIC ON CANVAS

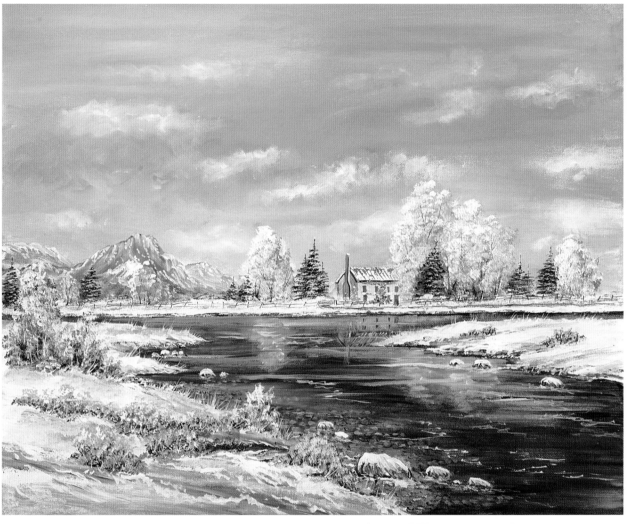

Paints:

 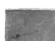

| Payne's gray | cobalt blue | alizarin crimson | raw sienna | Hooker's green deep | yellow light hansa | burnt sienna | titanium white |

Considerations:

- Soften the cloud edges by blending with your finger, using circular movements.
- Position the horizon line less than halfway up the canvas.
- Reflect the sky colours in the water.

How it was painted:

- Sky – Whopper brush used to cover canvas with cobalt blue and titanium white mix.

- Cumulus clouds – Painted in with titanium white with a little Payne's gray added to represent cloud shadows; blended in with a finger.
- Underwater rocks – Painted with the 20mm (¾ in) flat brush loaded with a burnt sienna and titanium white mix. Shadows underneath the rocks were added with Payne's gray and burnt sienna. When dry the water was painted over the rocks using a thin glaze so that the rocks can still be seen under it.

- Trees and bushes – Painted with the Derwentwater brush.

Techniques:

- Cumulus Clouds on Canvas, page 70.
- Riverbanks, page 116.
- Running Water and Rocks, page 117.

Canvas:

Winsor & Newton stretched canvas, 610 x 510mm (24 x 20in)

Colourful Landscape Exercise – 'Wilderness'

ACRYLIC ON CANVAS

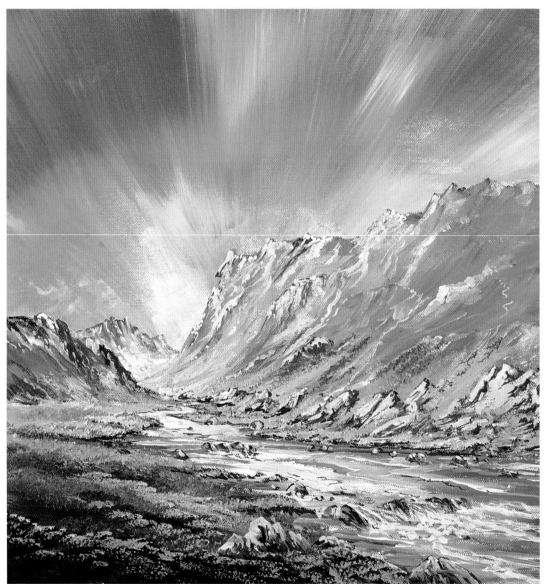

Paints:

Payne's gray

cobalt blue

alizarin crimson

raw sienna

Hooker's green deep

yellow light hansa

burnt sienna

titanium white

Considerations:

- Direct the brushstrokes in the sky towards the distant mountain pass.
- Define the mountain crags.
- Shape the river to lead the eye into the painting – wider in the foreground, narrower in the distance.

How it was painted:

- Sky – Cobalt blue over a raw sienna and titanium white background.

A little alizarin crimson was added to the mix on the left-hand side to produce a soft violet.
- Mountains – Painted in lighter values in the distance to create recession.
- Water – Cobalt blue and titanium white mixes painted lighter in the distance with a 20mm (¾ in) flat.
- Foreground – The 'Unique' brushes were used to stipple in texture, working from light yellow green in the distance to a darker foreground.

Techniques:

- Perspective, page 71.
- Background Sky, page 92.
- Running Water and Rocks, page 117.

Canvas:

Winsor & Newton canvas board, 406 x 406mm (16 x 16in)

Colourful Landscape Exercise – 'Nostalgia

ACRYLIC ON CANVAS

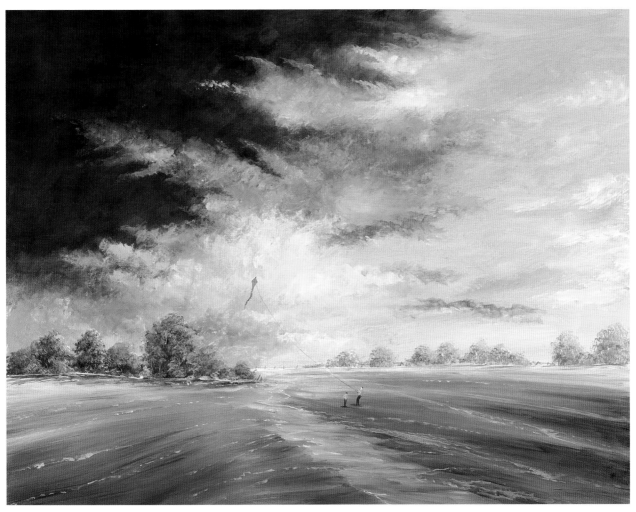

Paints:

cobalt blue · alizarin crimson · raw sienna · burnt sienna · titanium white · Hooker's green deep

Considerations:

- Position a piece of 20mm (¾ in) masking tape over the whole horizon allowing you to paint the sky down to this line. After the sky is painted, paint in the distant bushes and trees. Remove the masking tape to reveal sharp lines.
- When painting the land area, notice the direction of the brushstrokes.

How it was painted:

- Sky – Painted with the Whopper brush. Pale blue under-painting followed by raw sienna and titanium white clouds followed by darker clouds using a cobalt blue, alizarin crimson and burnt sienna mix.
- Trees – Stippled in using the Derwentwater brush loaded with Hooker's green deep, raw sienna and titanium white mixes.
- Land area – Painted with the same colours as the sky.
- Figures – See page 26.

Techniques:

- Perspective, page 71.
- Trees, page 93.

Canvas:

Winsor & Newton stretched canvas, 760 x 610mm (30 x 24in)

Colourful Landscape Exercise – 'Moonlight'

ACRYLIC ON CANVAS

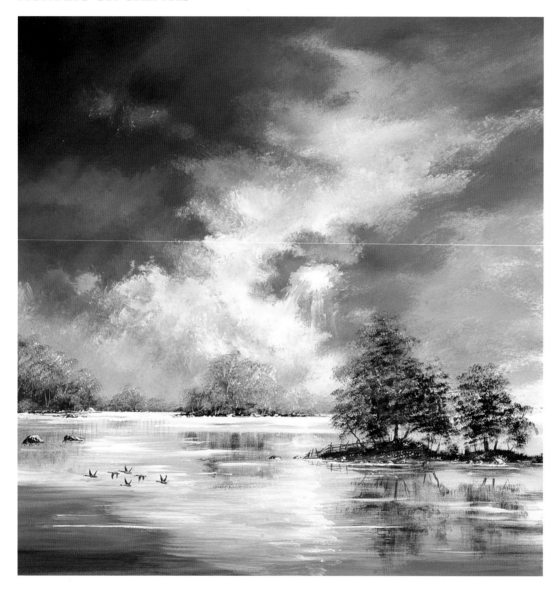

Paints:

Payne's gray

cobalt blue

titanium white

Hooker's green deep

Considerations:

- Paint the sky in a variety of blues with a light area representing moonlight.
- Paint the distant trees in a lighter tonal value.
- Paint the moonlight shining across the lake.
- Add some geese heading for their roost – see page 28.

How it was painted:

- Sky – Using the Whopper brush with mixes of Payne's gray, cobalt blue and titanium white.
- Trees – Using the Derwentwater brush loaded with Hooker's green deep, cobalt blue and titanium white mix.
- Water – Painted with sky colours using horizontal strokes.
- Reflections – Painted by dragging the brush downwards with the tree mix.

Techniques:

- Cumulus Clouds on Canvas, page 70.
- Tree Foliage, page 72.
- Tree Colour and Reflections, page 115.

Canvas:

Winsor & Newton stretched canvas, 914 x 914mm (36 x 36in)

Colourful Landscape Exercise – 'Evening Glow'

ACRYLIC ON CANVAS

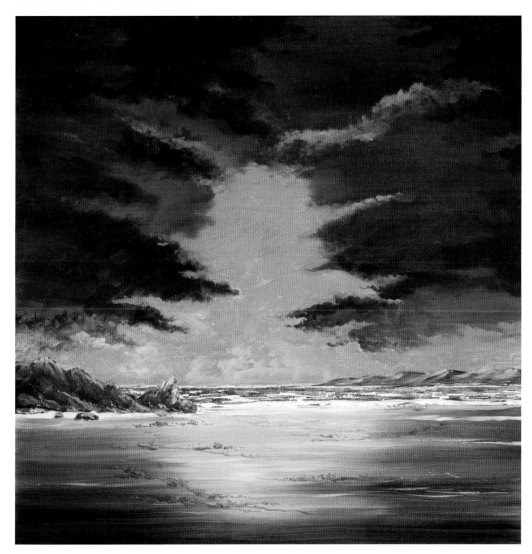

Considerations:

- The horizon should be no more than one third of the way up the canvas.
- Use the Whopper brush to paint the sky. Soften the edges of the clouds with circular movements of your finger.

How it was painted:

- Sky – Using the Whopper brush, a raw sienna under-painting was over-painted with burnt sienna, Payne's gray, cadmium red, raw sienna and titanium white mixes. The cloud profiles were blended with a finger or a soft brush.
- Sea – Painted with the edge of a 20mm (¾ in) flat loaded with cobalt blue plus a small amount of cadmium red to reflect the sky. Titanium white applied to represent waves.
- Beach – Horizontal strokes using the sky colours with a patch of raw sienna in the centre.
- Rocks – Painted with a 20mm (¾ in) flat brush and mixes of burnt sienna, Payne's gray and cadmium red, with a raw sienna and titanium white mix for highlights.

Techniques:

- Sandy Beach, page 40.
- Cumulus Clouds on Canvas, page 70.
- Rocks Using a Palette Knife, page 106.

Canvas:

Winsor & Newton stretched canvas, 610 x 610mm (24 x 24in)

Index